Drawing in Pencil

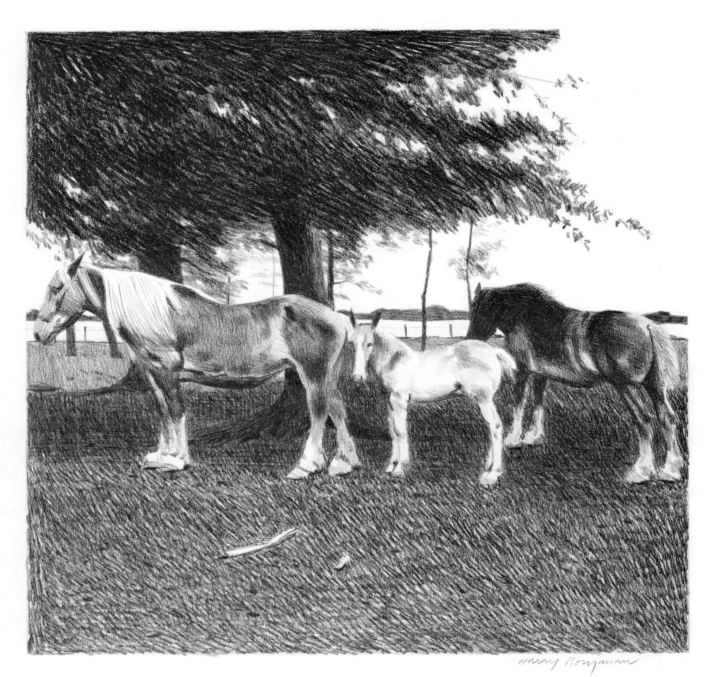

Fig. 1 MEADOWBROOK FARMS, *11 9/16″x11¼″ (29.4 x 28.6 cm).*

Drawing in Pencil

By Harry Borgman

*A Complete Guide to Drawing Techniques
in a Variety of Pencil Media*

WATSON-GUPTILL PUBLICATIONS/NEW YORK

Copyright © 1981 by Watson-Guptill Publications

First published 1981 in the United States and Canada by Watson-Guptill Publications,
a division of Billboard Publications, Inc.,
1515 Broadway, New York, N.Y. 10036

Library of Congress Cataloging in Publication Data
Borgman, Harry.
 Drawing in pencil.
 Includes index.
 1. Pencil drawing—Technique. I. Title.
NC890.B67 741.2'4 81-13007
ISBN 0-8230-1387-1 AACR2

Manufactured in U.S.A.

First Printing, 1981

1 2 3 4 5 6 7 8 9/86 85 84 83 82 81

To David and Terry Lindsay

Contents

Introduction

The pencil is a well-known tool that almost everyone uses for writing, if not for drawing. Therefore, the beginning art student usually finds it a familiar, natural drawing instrument. It is simplicity itself. With it and a sheet of paper, you are ready to start drawing.

One of the advantages of the pencil is that it can be used in so many ways. Just by sharpening the lead point differently, you can create distinctively drawn lines. And the various grades of lead, from very hard to very soft, produce even more variety, both in line and in tone. You can create drawings by using only lines, by using tones devoid of lines, or by employing any number of techniques in between. Pencil is also compatible with a wide variety of paper surfaces whose textures can add a great deal of interest to a drawing. Individual ways of drawing, based on the artist's point of view, also add dimension to the pencil medium.

The Potential of Pencil

So far I have written about only the basic graphite pencil, but there are many other kinds, such as color pencils, which can open up whole new worlds for drawing exploration. Pencil can also be used with other mediums, since it combines well with markers, dyes, inks, watercolors, and other paints, and can introduce the artist to other mediums. As you can see, the pencil is a unique drawing tool, one that is ideal for your own training and development as an artist.

The pencil is actually inseparable from art, since most works—such as paintings, ink drawings, illustrations, lithographs, engravings, and even sculpture—invariably begin as pencil drawings. Not only is the pencil ideal for preliminary work, it is also well suited for highly finished drawings that are an end in themselves. But because the pencil is most often used for preliminary work and sketches, few artists develop their pencil techniques to any degree.

The purpose of this book is to explore the diverse possibilities of pencil. When you consider the many kinds of pencils available, as well as the great variety of paper surfaces on which to use them, the full scope of this medium becomes apparent. With the added dimension of color, which has rarely been covered in other drawing books, this exploration becomes even more exciting.

On the following pages you will find examples of many pencil techniques and drawing styles, done on various paper surfaces. The subject matter is diverse and includes outdoor scenes, figures, portraits, animals, buildings, and still-life subjects. For comparison I have occasionally used different techniques to draw the same subject. To explore the differences between various drawing tools, I have included drawings done with graphite, charcoal, carbon, pastel, and wax-type pencils. Other examples include work done with related drawing tools, such as mechanical pencils, charcoal sticks, Conté crayons, and even oil crayons. These encompass a wide range of drawing, from very rough sketches to highly finished works. In addition, to help you better understand how many of these drawings were done, I have included fifteen step-by-step demonstrations. These demonstrations were photographed as the drawings progressed through the various stages so that you can see exactly how they were done.

Demonstrations 1 through 9, which are in black and white, include drawings done with graphite, charcoal, carbon, pastel, and wax-

type pencils. The techniques used in these demonstrations vary a great deal, which should help you to understand the variety that is possible. For example, the wax-pencil demonstrations include a water-dissolved pencil technique and a highly finished type of rendering.

In the color section, you will also find many drawing examples. They incorporate different techniques and six step-by-step demonstrations done on papers of different colors, textures, and surfaces. The book then goes on to show you how to use pencils with other mediums. You will find several examples and full-color step-by-step demonstrations done with color pencils and dyes, color pencils with gouache and oil crayon, and color pencils with acrylic paint. Immediately following these demonstrations is a section showing examples of black-and-white mixed media.

How to Use This Book

Rather than thinking of this book as a basic drawing manual, think of it as a complete pencil-technique guide that details how you can develop your pencil drawing skills. To get the most out of it, you should already have some knowledge of basic drawing. The examples shown throughout are a comprehensive collection of techniques that should be studied carefully and often. This is because a great deal can be learned through observation.

The exercises in this book are planned to help you learn about the tools that you will be using—what they are capable of and what their limitations are. Do not skip doing these exercises; they are a very important part of the book. In fact, I would suggest that you do all the exercises several times, using various paper surfaces and kinds of pencils. Above all, study the step-by-step demonstrations so you really understand how the drawings were done. It is equally important that you

familiarize yourself with all the drawing tools, which means actually working with all of them on many different paper surfaces.

Keep in mind that an art instruction book can only help to make you aware of the various tools, techniques, and some of the possibilities for experimentation. You must go on from there. You can help yourself a great deal by enrolling in a basic drawing or life-drawing class. Working with a competent, professional drawing instructor can prove invaluable, and being in a drawing class will give you an opportunity to meet other artists and see how they approach drawing problems. You will also have a chance to discuss art with people who share your interest.

In this book I hope to encourage you into experimenting and exploring the endless possibilities of pencil and, perhaps, to help you develop a personal drawing style. This will of course happen only if you consistently practice your drawing.

Developing your ability to draw is important, for it can be the basis for all your future artwork. As you develop your drawing skills, you will be able to move into more difficult areas of art, such as painting. Used properly, this book can provide you with the necessary background for your development as an artist. Keep in mind that an art instruction book should be *used*, not left sitting on a library shelf.

It is also important to remember that being an artist requires self-discipline. This can often be more important than talent. Without discipline, it is doubtful whether you can even develop as an artist. Remember, no one will tell you when to do a drawing or force you to work; you must be self-motivated. One of the most important things you should learn from this book is that you can grow and develop as an artist only by working at it consistently.

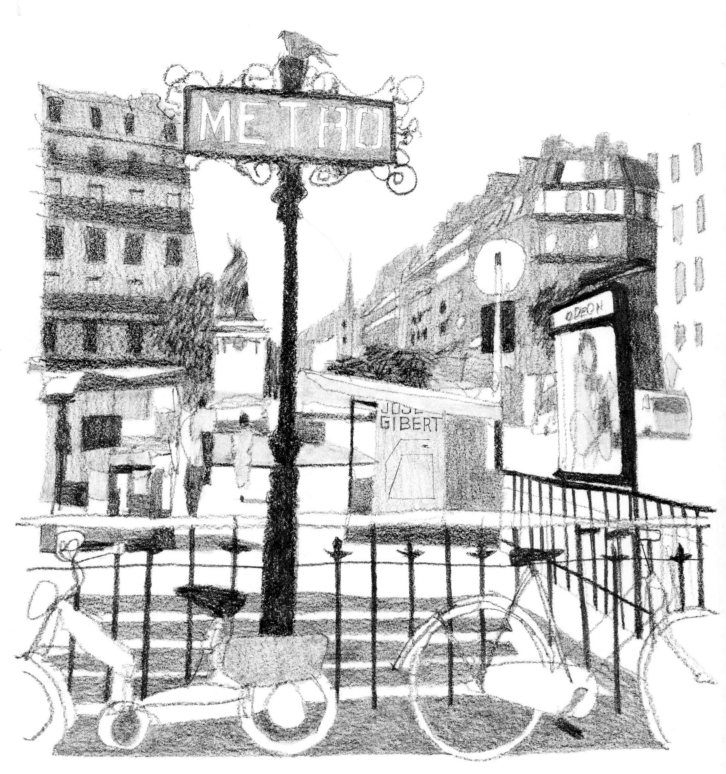

BOULEVARD ST. GERMAIN, PARIS, *9½″ x 10″ (24.1 x 25.4 cm)*. This drawing was done on a slightly textured paper surface with a Koh-i-noor Hardtmuth 350 Negro pencil, grade 2. This pencil is a delight to use and became one of my favorites while working on this book. The technique here is quite simple, employing only line with very flat tones. The final effect is rather decorative and lends a certain charm to the drawing.

Materials and Tools

Pencil drawing can actually involve a minimal amount of equipment—just a pencil and a scrap of paper are all you need to start. But if you are serious about your work, you will need more than that. You will need to know about the many possibilities available in this medium. One way to gain more confidence in your drawing, so that you can move from the simple to the complex, is to learn about your drawing tools and how to handle them. This chapter will tell you what the best materials are and how to use them.

Pencils

Fortunately for artists and art students, there are a great variety of drawing pencils available, as well as many excellent paper surfaces to work on.

Graphite Pencils. The traditional basic drawing tool—the graphite pencil—is made of compressed graphite that is encased in cedarwood. It is available in many different grades, ranging from very hard to very soft. The order of grading is: 9H, 8H, 7H, 6H, 5H, 4H, 3H, 2H, H, HB, B, 2B, 3B, 4B, 5B, and 6B. The 9H lead is the hardest grade, and the 6B is the softest. Personally I prefer using the HB grade for general work and often use the H and 2H grades as well. You should experiment with a few of the different grades to see which ones you prefer. Generally speaking, the harder grades work better on smooth, hard-surface paper, while the softer grades work better on textured paper. You may not agree with me on this, and only by experimenting with a variety of materials will you find the combinations that best suit you.

Regarding the lead grades, the harder the lead, the lighter the line; the softer the lead, the darker the line. The harder grades above 2H are usually used for drafting or for mechanical drawing, while the softer grades are used for general drawing. For sketching, the very soft grades—2B through 6B—are best; the harder 2H to B grades are better for meticulous renderings.

There are many fine brands of graphite pencils available, and you will have to try a few of them to see which you prefer. Some brands that I have found to be excellent are Berol Eagle Turquoise, Koh-i-noor, Mars Lumagraph, and Venus. Other types of graphite pencils are available, and some that are especially suited for sketching have very broad, flat leads for drawing thick lines. These sketching pencils usually come in grades of 2B, 4B, and 6B. The Ebony pencil, which has a large diameter and a very black lead, is also quite good.

Charcoal and Carbon Pencils. There are also many types of charcoal and carbon pencils on the market. A good brand is General Charcoal. It is a deep black and comes in grades of HB, 2B, 4B, 6B, and white. Wolff carbon pencils are also quite good, and they come in grades of HH, H, HB, B, BB, and BBB, which is the softest.

Wax-Type Pencils. One of my favorite drawing pencils is the Koh-i-noor Hardtmuth Negro pencil. It has a wax-type lead that is jet black and it is available in five degrees of hardness. Many other wax-type pencils are on the market; some have very fine leads, while others have very soft, thick leads.

I find the Berol Prismacolor pencils excellent for drawing and sketching. Their leads are smooth, thick, and strong enough to sharpen to a fine point. Their color range is wide, comprising sixty colors. Prismacolor pencils can be purchased singly or in sets of 12, 24, 36, 48, or 60 colors. These pencils can

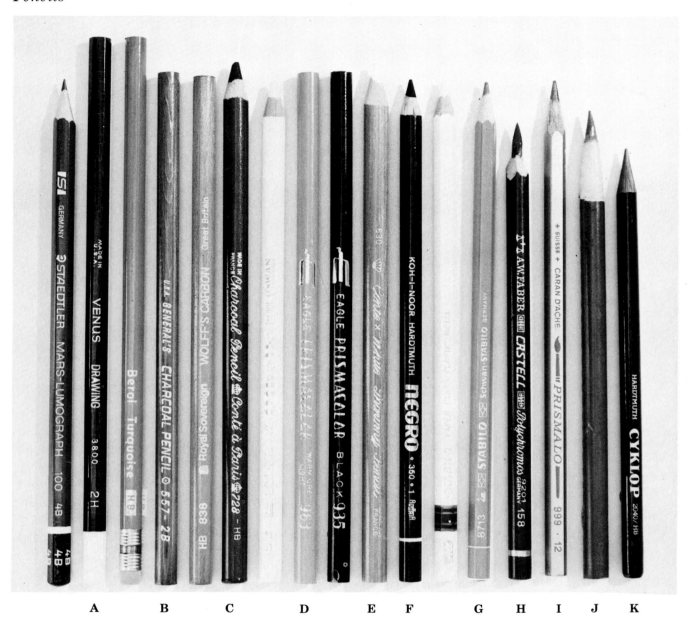

A. Graphite
B. Charcoal and carbon
C. Carb-Othello pastel
D. Berol Eagle Turquoise prismacolor
E. Conté white
F. Koh-i-noor Hardtmuth Negro
G. Stabilo
H. Faber Castel Polychromos
I. Caran D'Ache Prismalo water-soluble
J. China marking pencils and litho crayons
K. Hardtmuth Cyklop

A. Graphite
B. Charcoal and carbon
C. Carb-Othello pastel
D. Berol Eagle Turquoise prismacolor
E. Conté white
F. Koh-i-noor Hardtmuth Negro
G. Stabilo
H. Faber Castel Polychromos
I. Caran D'Ache Prismalo water-soluble
J. China marking pencils and litho crayons
K. Hardtmuth Cyklop

also be used in conjunction with other mediums, such as markers, dyes, watercolors, and other painting mediums. They can be blended or smudged with a paper stump dampened with Bestine, a rubber-cement solvent. I have used Prismacolor pencils for many years and have found them to be uniform in color and lead consistency.

China Marking Pencils. These can also be used for drawing. They are available in several colors, including white, black, brown, red, blue, green, yellow, and orange. Stabilo, another wax-type pencil, is also available in eight colors.

Water-Soluble Pencils. Another interesting pencil is the Caran D'Ache water-soluble pencil. You can wash clear water over the drawn lines with a brush and dissolve the tones, creating a pencil painting. You can also use Caran D'Ache pencils without dissolving the tones. This brand offers forty brilliant colors, whose strong leads can be sharpened to a fine point. There are other types of water-soluble pencils on the market, so you can check your local art supply dealer about their availability.

Pastels. These are available in pencil form and are a very interesting medium to work with. They can be blended easily with your fingers or a paper stump and are especially suitable for soft effects. The brand I use is Carb-Othello. It is available in sixty colors, with matching pastel chalks that can be used for covering large areas. These pencils sharpen well for detailed work and have a large-diameter lead that can be used to draw broad strokes.

Conté Crayon. Conté crayons, which are very good for sketching, come in black, white, sepia, and sanguin. A pencil form of the crayons is also available in three grades of hardness.

Miscellaneous. Another good sketching tool is the graphite stick, which is available in many grades and in a round or square shape.

There are all kinds of lead holders and mechanical-type pencils you may want to try. Many grades of replacement lead for the holders are available in most art-supply stores. Another great sketching tool is the charcoal stick, which also comes in several grades of hardness.

Drawing Accessories

Masking Tape. You can use masking tape to stick your drawing paper to a drawing surface.

X-Acto Knife. Mechanical or hand-held pencil sharpeners are not the best tools to use for sharpening your pencils. The leads of pencils sharpened this way are usually too short and too dull. The X-acto knife method works best: you cut away the wood surrounding the lead and then shape the lead with a sandpaper block. The harder grades of pencils can be sharpened to a long point because the lead is stronger, but be careful with the softer grades, as they break rather easily. By using this method of sharpening pencils, you have the advantage of being able to shape the point any way you wish, depending on the effects you want to achieve when drawing. Be careful, however, not to sharpen the wrong end of the pencil, or you'll cut away the number identifying the lead grade. Incidentally, it's a good idea to sharpen several pencils at the same time so you can continue drawing without interruption. Experiment with the sanding block. The leads can be sharpened to a very sharp point for fine work or shaped to a blunt point for work requiring thicker lines. An interesting shape is the chisel point. When using this point, you can make very fine lines with the end or very thick lines with the flat surface of the point. Also experiment with effects you can achieve with the various points.

Charcoal pencils can easily be sharpened with an X-acto knife, then shaped with a sanding block. Because charcoal and carbon leads are thicker than graphite, they can

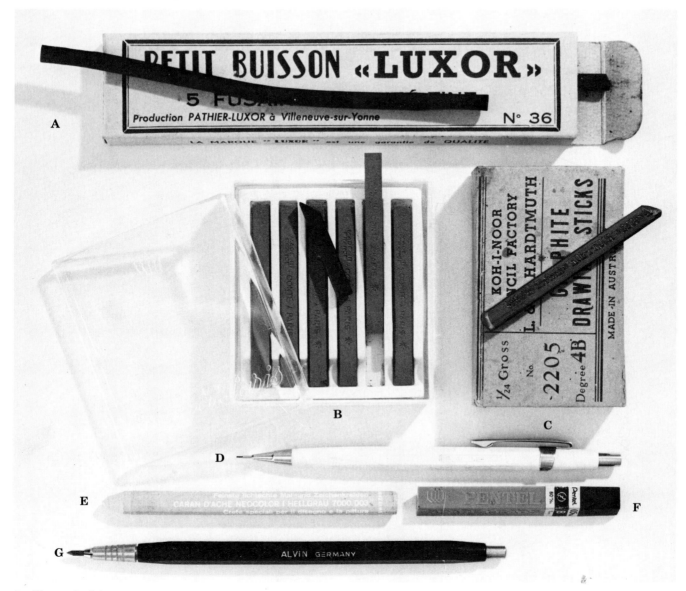

A. Charcoal stick
B. Conté crayon
C. Graphite stick
D. Mechanical pencil
E. Oil crayon
F. Refill leads for the mechanical pencil
G. Lead holder

Drawing Aids

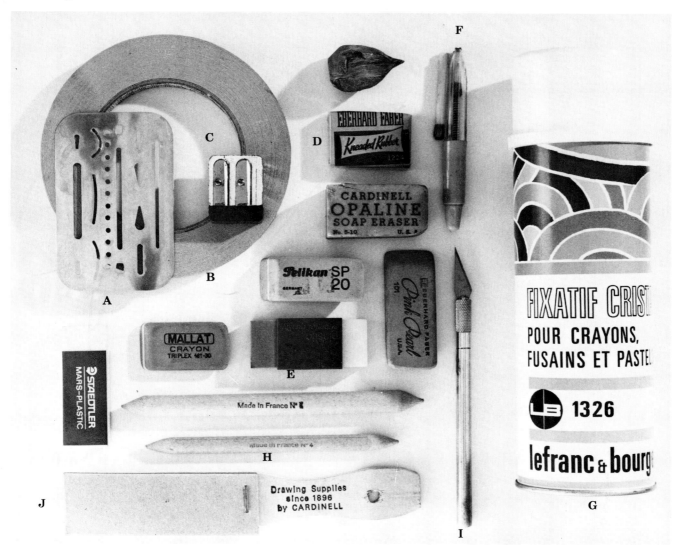

A. Erasing shield
B. Masking tape
C. Pencil sharpener
D. Kneaded rubber eraser
E. Various erasers
F. Fiberglass eraser
G. Fixative
H. Rolled paper stumps
I. X-acto knife with a number 11 blade
J. Sandpaper block

take on more shapes. The same holds true for pastel pencils—but be very careful when shaping these points, as they are soft and tend to break easily. Graphite sticks and Conté crayons can be sharpened to a variety of forms with the sanding block. You can draw with the different edges of these sticks and achieve very distinctive results. If you prefer an even line when drawing, try using a mechanical pencil with a fine lead.

Erasers. There are many types of erasers available, but the most useful is the kneaded rubber type. This is a soft, pliable eraser that can be shaped to a point for picking out highlights or erasing in tight spots. The kneaded eraser is soft, and its nonabrasive texture won't damage your drawing. Artgum erasers are safe and efficient for cleaning drawings, and they also won't mar or scratch. Of the several vinyl-type erasers that are quite useful, Magic Rub, Edding R-20, and Mars-Plastic are three good brands. Pink Pearl erasers, which are soft and relatively smudge free, are good for all-around use. Electric erasers are also available, but they are generally used for tougher erasing jobs, which you might encounter when doing India-ink drawings. An erasing shield is a handy item that can be used to confine the area you're erasing.

Sandpaper Block. This is essential for shaping your pencil leads after you have cut away the wood with an X-acto knife. These sandpaper blocks consist of twelve sheets of sandpaper, padded and mounted on a wooden block. The sanding block can be used on all types of pencils and on graphite sticks and Conté crayons. As the sandpaper becomes saturated with graphite, just tear off the used sheet and expose a fresh one.

Fixatives. You will want to protect your pencil drawings so they don't get ruined through smearing or smudging. This can easily be done by spraying the drawings carefully with a varnishlike liquid called fixative. Fixative is available in spray cans or in bottles for use with an atomizer. However, since it is much easier to achieve a smooth coating of fixative by using the spray can, I would recommend this method. The spray fixative is available in two types—glossy or nonglossy, which gives a matte finish. The matte finish is the best to use for pencil drawings.

Papers

There are many drawing papers and illustration boards that can be used for pencil drawings. The following are a few of the basic types that are most suitable for this medium.

Tracing Paper. This is a general all-purpose paper with a fine transparent surface. Usually tracing papers are used for rough preliminary sketches and for multiple drawings in which the artist draws over previous sketches to improve them. Tracing paper is available in pads ranging in size from 9″ x 12″ (22.8 x 30.4 cm) to 24″ x 36″ (61 x 91.4 cm). It is also available in rolls of varying widths and lengths.

Layout and Visualizing Paper. Layout papers are excellent, especially those that are top quality. This type of paper has a velvety smooth surface and is semitransparent, making it ideal for all pencils. It is available in the same pad sizes as tracing paper.

Newsprint. This paper comes in either a smooth or a textured surface. It is suitable for doing lots of quick sketches in charcoal and is perfect for use in a life-drawing class. It is available in pads ranging in size from 12″ x 18″ (30.5 x 45.7 cm) to 24″ x 36″ (61 x 91.4 cm).

Hot- and Cold-Pressed Bristol Board. Hot-pressed board, which is also called *plate-finish* or *high-finish* bristol, has a smooth, hard surface. It is usually used for India-ink drawings, but is also excellent for pencil drawings. Cold-pressed board is a versatile paper because its slight surface texture is well suited for many mediums, including

Paper Surfaces

A. Smooth surface or high-finish bristol (also called plate finish).
B. Ingres Canson—a slightly textured surface.
C. MBM Ingres D'Arches—a more evenly textured surface.
D. Aussedat Annecy—a soft, less machinelike surface.
E. Lavis B—a slightly rough-textured surface.
F. Regular-surface bristol—a slightly textured surface.
G. Layout paper—a fine, smooth surface.
H. Tracing paper—a very smooth surface.
I. Colored papers—slightly textured.

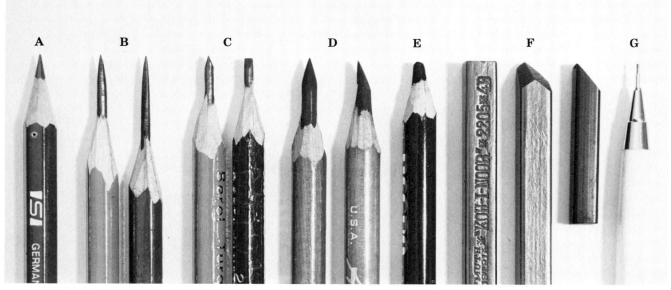

A. Pencil pointed with a sharpener
B. Sharpened with an X-acto knife and a sanding block
C. Chisel-pointed with a sandpaper block
D. Two ways to sharpen charcoal pencils
E. Blunt point for heavier lines
F. Graphite sticks with different drawing edges
G. Mechanical pencils for thin, even lines

pencil. The bristol board I generally use is made by Strathmore and is available in both the high finish and the cold-pressed, which they call regular surface. This fine-quality paper comes in various thicknesses, from 2-ply to 5-ply, which is the heaviest. Both surfaces are also available in heavier illustration board, which you may prefer. Strathmore bristol papers are 23″ x 29″ (58.4 x 73.7 cm).

Another fine brand of bristol board is Schoeller. I prefer this brand for India-ink drawings because its surface seems to be more durable—an important point to remember is you have to make corrections with a fiberglass eraser. Also available is a rough, coarsely textured paper that is generally more suited for watercolor techniques but which can be successfully used for certain types of pencil drawings.

Watercolor Papers. Other interesting paper surfaces on which to work are watercolor papers, also available in hot-pressed, cold-pressed, or rough surfaces. Watercolor paper can be purchased in separate sheets or in blocks of twenty-five sheets. The watercolor blocks range in size from 9″ x 12″ (22.8 x 30.5 cm) to 18″ x 24″ (45.7 x 61 cm).

Charcoal Papers. These are available in many different colors in a sheet size of 19″ x 25″ (48.3 x 63.5 cm). They can also be purchased bound in pads of assorted colors as well as in white. These pads range in size from 9″ x 12″ (22.8 x 30.5 cm) to 18″ x 24″ (45.7 x 61 cm).

Printing Papers. There are many types of cover stock, or printing papers, to choose from. They come in a variety of sizes and surfaces and are quite good for drawing. Check your local art-supply dealer or paper distributor to see what is available. Pantone makes a good paper in a range of five hundred colors. It is printed on a matte surface that works well for pencil drawings. The sheet size is 20″ x 26″ (55.8 x 66 cm).

Many unusual papers can also be found at printing-paper supply houses. I especially enjoy working on Kromkote, a paper with a very glossy surface that is perfect for wax-type pencils. Many printing papers have in-

Pencil Strokes

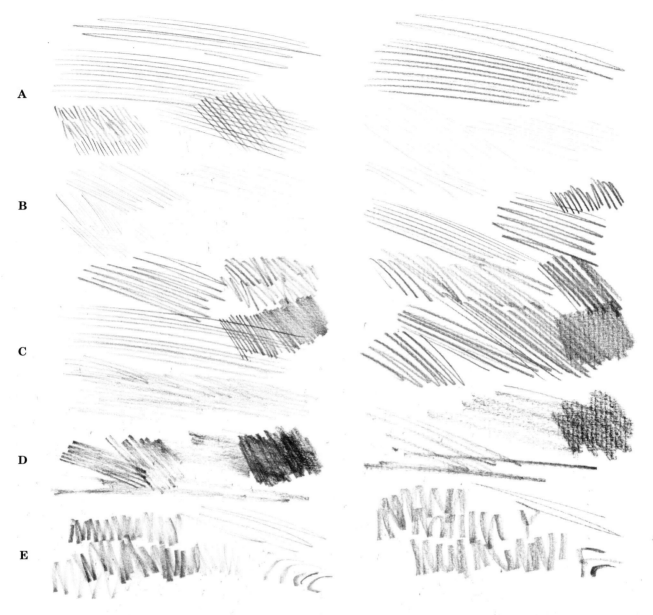

A

B

C

D

E

Pencil strokes shown here are done on two kinds of paper—
the left is a smooth, high-finish bristol, the right has a
slightly textured surface.
A. Mechanical pencil with grade B, 5mm lead produces
nice, even lines.
B. A hard 4H graphite pencil produces very fine, light
lines.
C. A softer grade HB pencil creates much darker lines.
D. The 2B charcoal pencil works less well on smooth paper,
but is fine on textured papers.
E. An HB pencil sharpened to a chisel point can produce
various line weights and tones depending on pressure used.

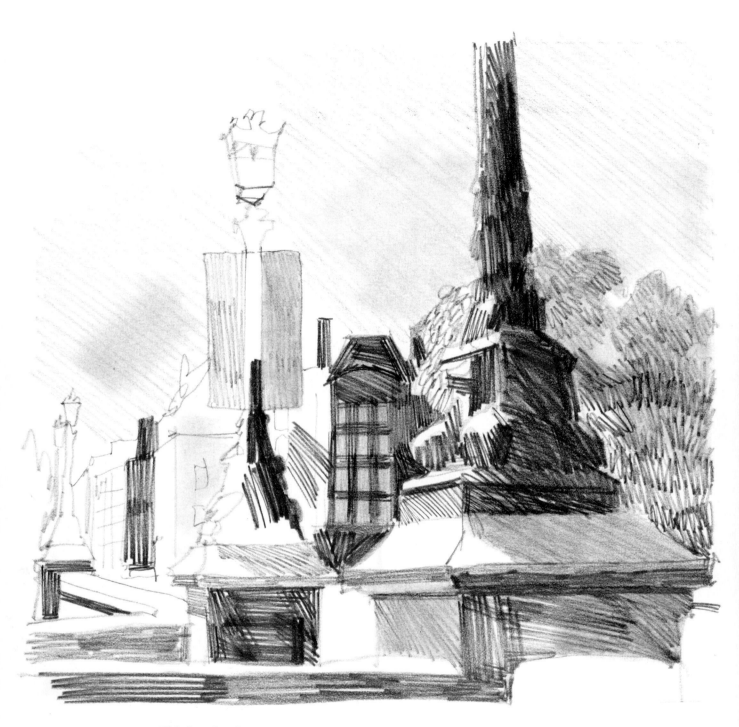

This drawing done with a 2B graphite pencil demonstrates the variety of
linear and tonal qualities possible with a graphite pencil. In the sky portion, a
series of lines creates a gray tone which was smoothed out with a rolled paper
stump. The zig-zag lines used in the trees to simulate foliage were also
rubbed with the paper stump to create a tone. You can experiment with dif-
ferent grades of pencils to see the various effects possible by rubbing the lines
with a paper stump. You can also dampen the stump with Bestine, a rubber
cement solvent that dissolves graphite to create interesting tonal effects.

teresting surface textures that are quite good to use for charcoal, carbon, or pastel pencil drawings.

Other Papers. I have experimented successfully with Japanese rice papers and lithograph printing papers. Vellum, a paper much like tracing paper, is also very good to draw on. And there are many illustration boards available. One I particularly enjoy has a linen-like texture that is excellent for pencil drawing.

Drawing Surfaces and Lighting

Drawing Board. Although you can use an ordinary table or even a desk to work on, I recommend using a portable wooden drawing board. These boards are quite handy and come in a variety of sizes, ranging from 16″ x 20″ (40.7 x 50.7 cm) to 31″ x 42″ (78.7 x 106.7 cm). You can tape your paper to such a board with masking tape and be ready to work. These boards are also ideal for outdoor sketching or for use in a life-drawing class.

Drawing Table. Many artists prefer working at a regular artist's drawing board or a drafting table. A drawing board can be tilted and locked at any comfortable working angle. Some drawing tables can even be raised or lowered in height. They can also be tilted to a horizontal position for use as cutting tables and many tables of this type can be folded for easy storage if you happen to have a space problem. There are also more expensive types of drawing boards, which have been perfectly counterbalanced and can be tilted and raised simultaneously—an excellent feature. There are many types of drawing tables available in every price range; you will have to be the judge of which type suits your needs best.

Taboret. This type of table is handy for storage of your tools and doubles as a convenient table on which to set things while you are working. Again, many types are available in various prices. Of course you may prefer using a wooden box or an old table rather than buying a piece of furniture. As for seating, any comfortable chair will do. I personally prefer one with armrests and casters, for easy movement.

Lighting. If you are going to be working by artificial light, you should invest in a fluorescent lamp, an excellent type of light for artists. Some fluorescent lamps are designed so that they can be clamped directly to your drawing table, but I prefer a model that rests on a floor stand. It enables me to easily change the angle of my drawing table without first removing the lamp—something you should take into consideration. There are many types of lamps available, and you can check your local art-supply store or look in a catalog to find one you like.

Your local art-supply store may not stock all of the items I have mentioned, but you should be able to find equivalent ones. You can also order supplies from an art-supply catalog if necessary. Just remember that in a catalog you will find other interesting items. Some are essential; others are meant only for the professional artist. Don't run out and buy all the gadgets available. There are many things in an art-supply store that are quite expensive and that you don't really need. Think carefully about what you'll need before you buy and purchase only what you will use. Limit yourself to the basics, especially if you are a beginner, and purchase the highest quality you can afford. Inexpensive art materials are not worth using, especially poor-quality brushes or paper.

Chapter Two
Pencil Exercises

Artists generally hold a pencil in the same position for drawing as they do for writing. This is especially true when they are seated at a drawing table. But when an artist draws standing at an easel, the position of the pencil is different. This is because the normal writing position is then uncomfortable. For quick sketching still another position may be more suitable.

Positioning the hand and pencil is a very personal thing, and only by experimenting will you find the position that is best for you. Therefore the following exercises should first be done using the normal writing position and then done using other hand positions. The exercises are planned to help you learn how to use your tools and to familiarize you with the pencil's capabilities and limitations. These exercises should be practiced until you become very confident and facile with the pencil. They should also be done using various grades of graphite pencil as well as other pencils, such as charcoal, carbon, pastel, and wax-type pencils.

The first exercise suggests types of lines you should practice drawing. Remember to do this exercise with different pencils on various paper surfaces. After you become proficient at drawing the lines, go to the next exercise. In it you will learn to build tones with lines and how to create crosshatch tones and smooth tones without lines.

In the third exercise you will learn how to create line textures, which is another way of building tones. Don't move through these exercises too quickly—practice until you can do them successfully.

The next exercise will show you how to draw the same object four ways by creating tones in different ways. And in exercise five you will learn how to create smooth tones by blending with a paper stump. Exercises six through nine will teach you how to draw the same object using different techniques. They will start with line only, advance to line and tone, then to tone only, and finally to smudged tone. The last two exercises will help you to interpret a subject in simple basic tones, which can then be easily translated into a simple pencil drawing. This particular group of exercises is specifically designed to help you learn to see.

It is most important that you practice drawing with the pencil every day, carefully doing all the exercises until you are proficient at them. They are designed to help you learn about your drawing tools. If you practice the exercises, you will also become proficient at using all the pencils mentioned in the book. The more time you spend practicing, working on these exercises, the more you'll learn about drawing.

WOODED AREA NEAR LE MANS, *10⅛″ x 18⅛″ (25.7 x 33.3 cm).* This is another drawing done with the Koh-i-noor Hardtmuth Negro pencil. The paper surface here is very smooth bristol and lends itself well to use with this particular pencil, which enables you to achieve jet-black tones.

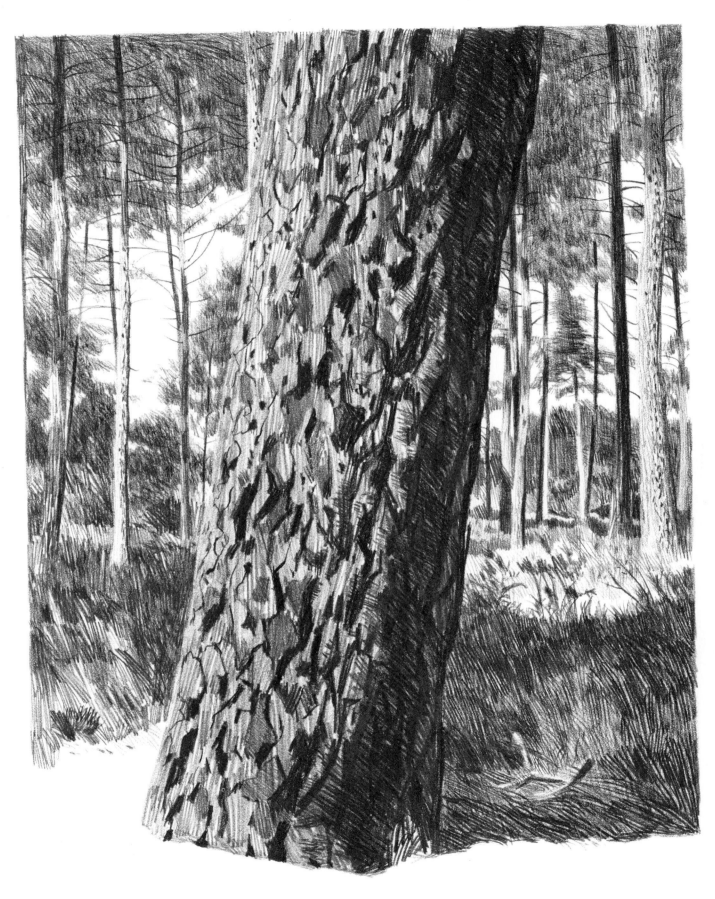

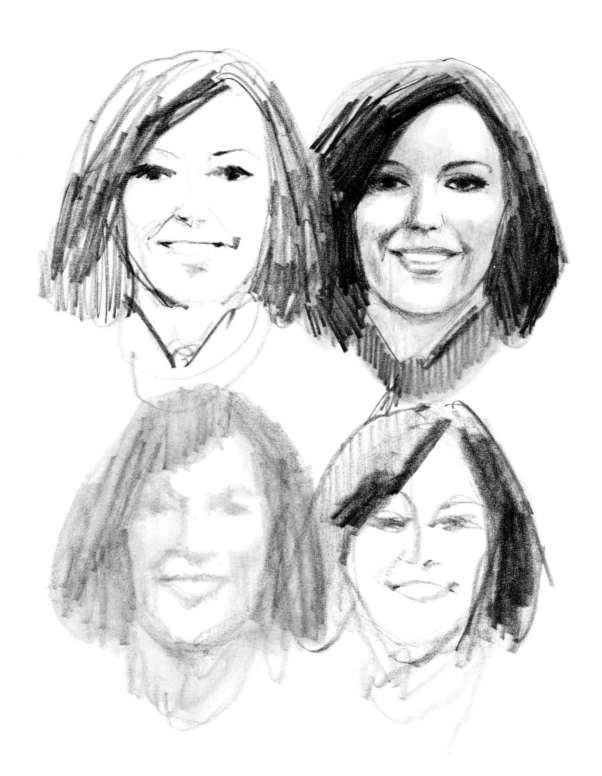

STUDIES FOR A PORTRAIT, *8½ x 11¾" (21 x 29.8 cm)*. These studies were drawn on a smooth-surface bristol board, using a Cyklop 2040 grade B graphite stick. This interesting drawing tool is in the shape of a pencil; it is round rather than square as is the usual graphite stick. The Cyklop has an outer coating, so you can use it without getting your hands dirty from the graphite. The sketch at the top left is done in a loose-line technique. The one next to it is much more finished, and incorporates blended tones. The sketch at the bottom left is primarily a smudged tone drawing utilizing a paper stump for blending. Below right is a very rough, quick sketch, with tones created by drawing with the Cyklop with varying degrees of pressure.

Exercise 1. Types of Lines

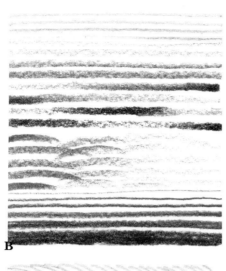

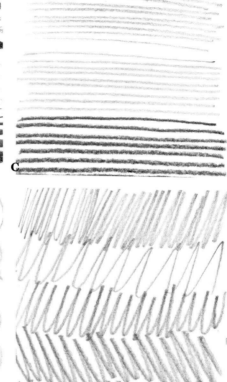

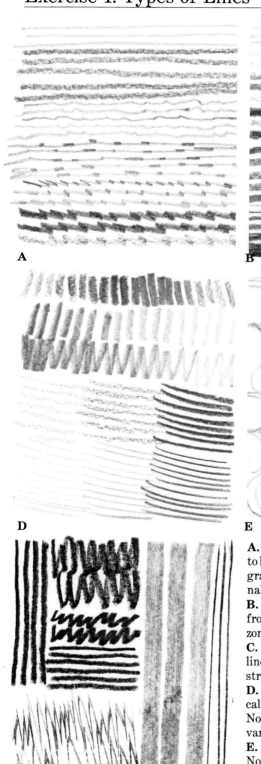

A. Practice drawing horizontal lines with a 2H or HB graphite pencil, trying to keep all the lines the same, even weight. Do the same with a softer 2B grade pencil. Then with the HB pencil, create a series of nervous lines. Finally, using different grades of pencils, draw a series of zig-zag lines.

B. With an HB graphite pencil, slowly draw horizontal lines, proceeding from light to dark. Do the same thing with a 2B and vary the pressure horizontally to achieve a variation of tone. Finish with thick, heavy lines.

C. Using various grades of pencils, practice drawing a series of horizontal lines using very quick strokes. Start with heavy strokes, then lighten the strokes toward the center and finish with strong, quickly drawn lines.

D. Using various grades of pencils, draw a series of pencil strokes in a vertical column, ending with heavy strokes. Repeat twice, using lighter strokes. Now draw a line of up-and-down strokes and two rows of vertical strokes of varying intensities.

E. Quickly draw a series of curved lines, first to the right and then to the left. Now try drawing the same curved lines very slowly. Practice with several different grades of pencils.

F. Practice drawing up-and-down strokes very quickly and then very slowly. Slant some strokes to the left and others to the right. Finish by drawing up-and-down strokes vertically without any slant at all.

G. Do a combination of exercises using other pencils such as Stabilo All, Koh-i-noor NOOR Hardtmuth Negro pencil, Conté crayon, and even charcoal stick. The right-hand portion of these examples illustrates the use of the flat edge of a Conté crayon. The fine lines illustrate the use of the crayon's edge.

Exercise 2. Building Line with Tone

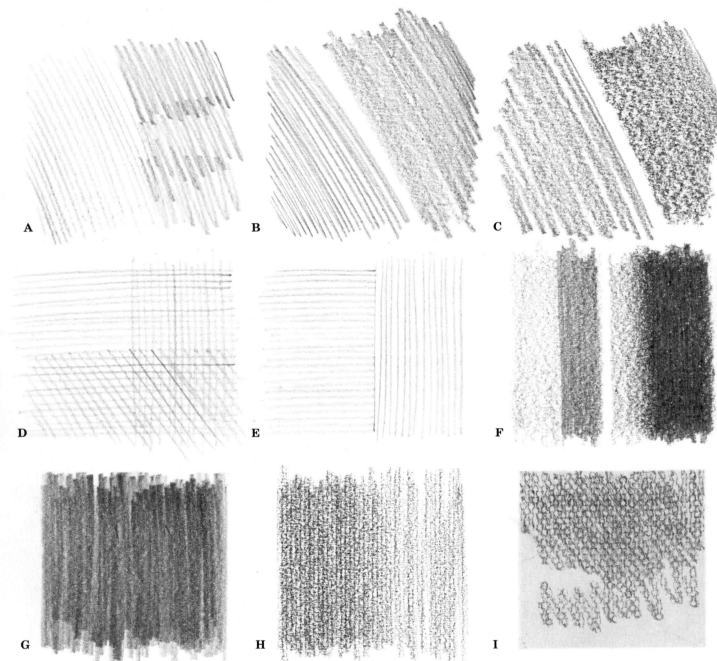

A. To create a gray tone, draw lines next to one another. Try this using lines of different weights with varying distances between them.

B. With an HB and then a 2B pencil, quickly draw lines close together without hesitation. Then create an even tone by moving the pencil slightly as you stroke across the paper so that no single pencil line shows.

C. Quickly draw close strokes with a 4B pencil, attempting to achieve an even gray tone. Try this also with a 6B grade pencil and notice how much darker the tone is than when drawing with the harder grades.

D. Cross-hatching is an interesting technique in which lines are drawn over each other to create tones. This technique is generally used for ink drawing, but it can be quite effective when done with pencil, especially the harder

grades such as 2H and HB.

E. It's very good practice to try drawing very evenly spaced lines. These should be drawn freehand without the aid of a ruler.

F. With a 2B pencil, first draw a very light, even tone and then a much darker one. Do the same with a 4B and a 6B, blending the tone into a very dense black.

G. Using strokes, try to create an even, gray tone. Draw dark ones as well as light ones.

H. Try blending pencil tones from dark to light with different types and grades of pencils on papers of varying textures.

I. Practice all of the previous exercises on a textured colored paper. Then do them all again, using a white pencil.

Exercise 3. Textures with Lines

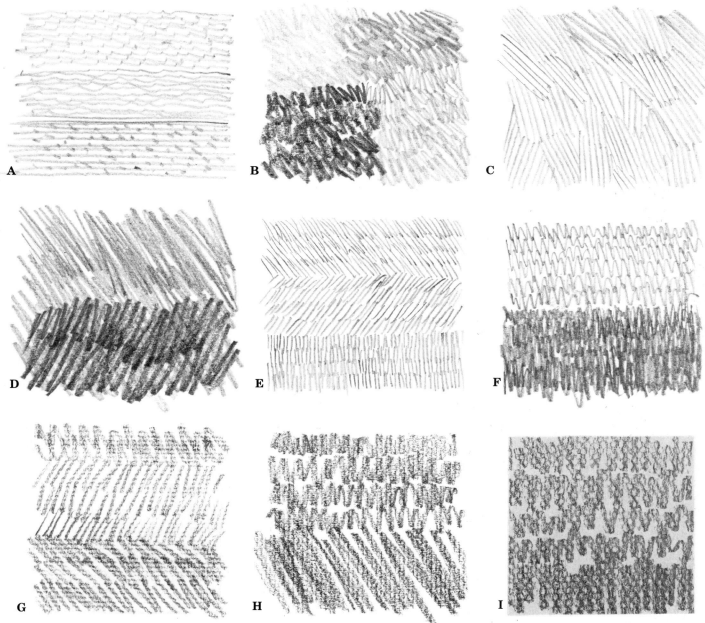

A. For all these exercises, use an HB pencil on a smooth bristol board. A series of half-loop lines can create an interesting texture and a series of wavy lines drawn closely together can create a fairly even tone. Now draw a series of even horizontal lines with short strokes or dots.

B. Zig-zag strokes drawn with varying pressure can also be used to create tones of different textures. Practice this using other pencil grades.

C. Draw one series of strokes followed by an adjacent series at a slightly different angle. Continue over a large area, constantly changing the angle of stroke. A very interesting textural tone will result.

D. Practice drawing textured, even tones using random zig-zag strokes. Over this tone draw another zig-zag tone, at another angle, using a darker-grade pencil.

E. Create a tone by drawing short strokes at an angle. The overlapping lines will create a slight texture. Do this exercise by also drawing strokes from the opposite direction.

F. Practice drawing a textured tone using a variety of strokes over an area. Then do the same thing with a softer-grade pencil, such as a 4B or 6B, keeping your strokes close together to achieve a darker tone.

G. Do all the above exercises on a textured paper and compare the results with those achieved on the smooth bristol.

H. Using pencils other than graphite, try the same exercises on a textured paper.

I. Do all the exercises on a heavily textured colored paper using first a black charcoal pencil, then a white charcoal pencil, and then black and white pastel pencils.

Exercise 4. Creating Tones

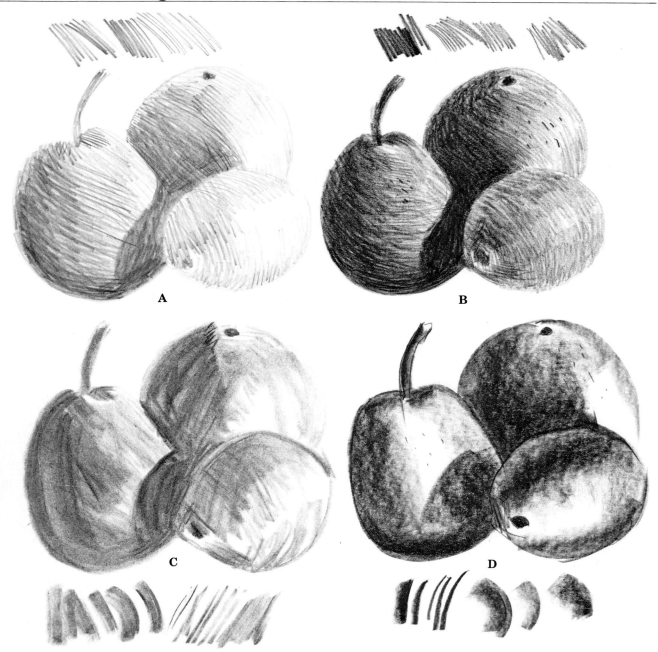

A. Practice drawing a simple object or objects such as this still life, creating all your tones with only lines. Don't attempt to blend any of the lines. Use an HB graphite pencil on smooth bristol paper. Small diagrams of various types of strokes accompany each sketch.

B. On smooth bristol, draw the same object with a 2B charcoal pencil. This time try to keep your tones fairly smooth and blended.

C. Now draw the same object using a soft charcoal stick. This can also be done on smooth bristol, but a textured surface will work better.

D. Draw the same object again, this time using a Conté crayon. You can use an edge at the top of the stick to draw very fine lines. To achieve broader strokes, break off a piece of the crayon and draw with the flat side. With just a little practice you will be able to create very interesting effects with the Conté crayon.

Exercise 5. Doing a Simple Still Life

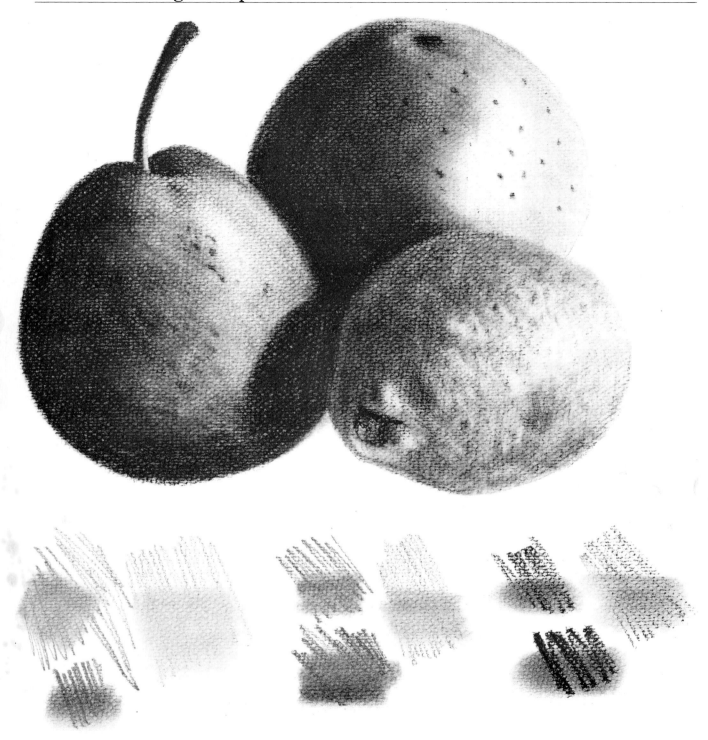

If you've diligently practiced all the preceding exercises, you should now be able to attempt a more detailed finished drawing of the same subject you used in the previous exercise. This drawing was done on a textured paper surface with a General charcoal 4B and a Wolff BB carbon pencil. The tones were blended with a paper stump. Below the drawing I demonstrate how various pencils can be smudged or blended using the rolled paper stump. The first group includes different grades of graphite pencils, the middle group illustrates various grades of charcoal pencils, and the last group shows different wax pencils.

Exercise 6. Still Life on Smooth Bristol

Here is a simple still life drawn on a smooth bristol board with a mechanical Pilot pencil using a grade B.5 mm lead. It is done very carefully, but in a simple manner using only an outline. You can also set up your own still life using objects around the house such as fruit, vegetables, flowers, or even kitchen utensils.

Exercise 7. Still Life on Canson Lavis

Now try drawing the same still life on a different paper surface using line and line-tone as shown here. Do not blend the lines, just use the lines to create your tones. Here I used HB and 4B grade pencils on Canson Lavis B paper.

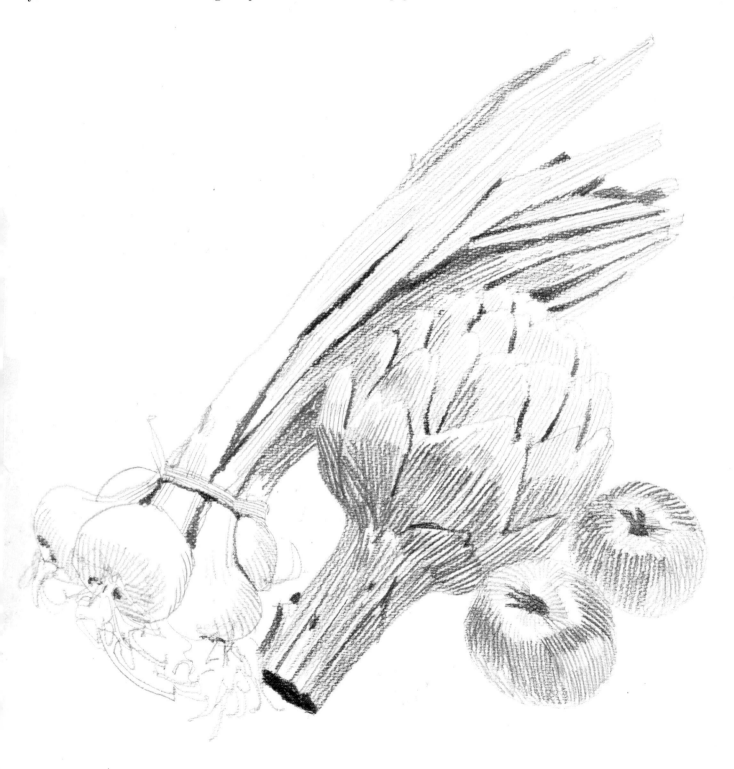

Exercise 8. Still Life on Layout Paper

Draw the same subject on a different paper surface using blended tones. This can easily be accomplished by first drawing all your lines quite closely together and then smoothly blending these strokes. This drawing was done on layout paper with an HB pencil.

Exercise 9. Still Life on Tracing Paper

Once more draw the same subject on a different paper surface. This time use a paper stump to smoothly blend your pencil tones. This drawing was done on tracing paper placed directly over my original drawing (Exercise 6) and traced through. I carefully added all the gray tones, blending them with the paper stump, and then I picked out white highlights with a kneaded rubber eraser. When you practice drawings like these, keep your subject matter fairly simple. You can set up still lifes, you can work from life, or you can take Polaroid photographs and draw from them. As you progress and gain more confidence, you can draw more complex subjects such as scenes and portraits.

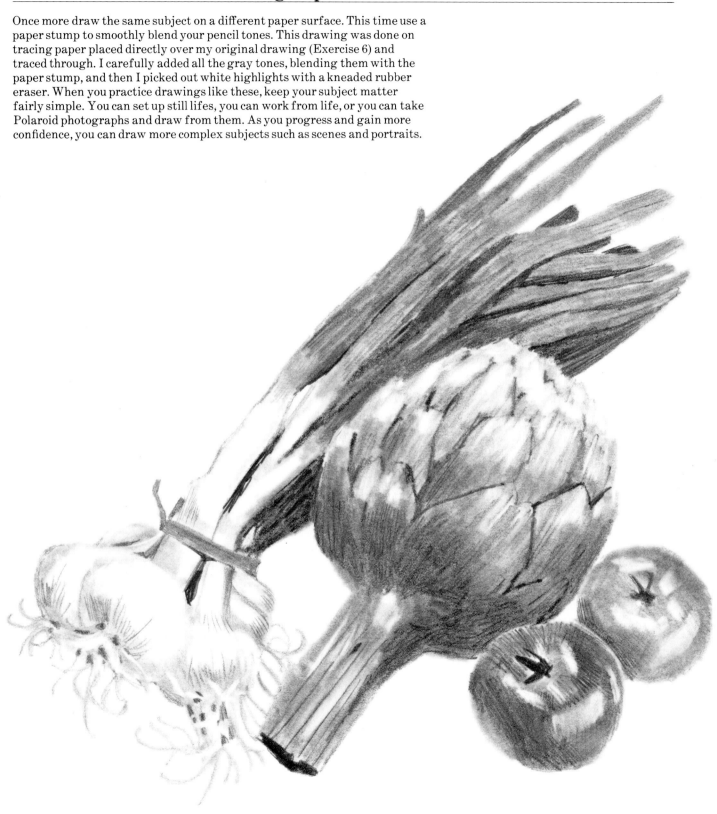

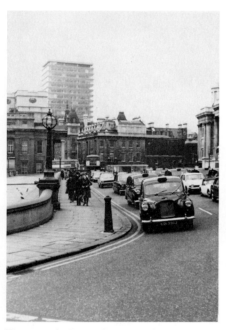

Frequently I use photographs as reference material, as it is often not practical to draw from life. I always carry a camera with me in case I see good subjects for picture ideas. Here is a photograph taken while on a trip to London.

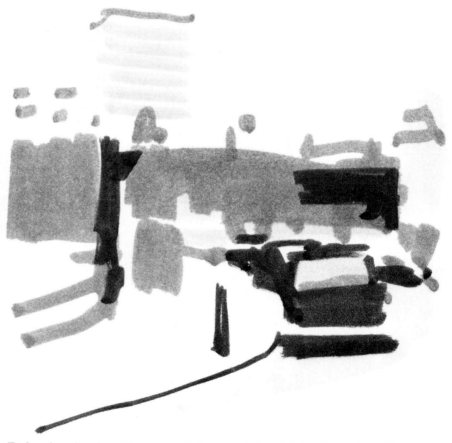

To do a drawing from the above photograph, I first tried to break down the scene into very simple gray values or tones. Here I have used Magic Markers to illustrate how this can be done. From this tonal breakdown, it is quite easy to do a pencil drawing.

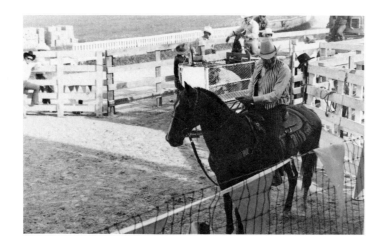

This is one of a series of photographs taken at a rodeo in Michigan. The scene appears quite complicated, but it can still be simplified into a few simple gray tones.

Here is how I broke down the above scene into three tones, black and two grays. Diagrams like this make it a lot easier to translate your subject into a finished drawing. I don't necessarily do such a tone breakdown for every drawing, but I do mentally try to view the object or scene in exactly this manner. You will find that you can train yourself to think and visualize in this way through practicing simple Magic Marker tonal breakdowns of photographs.

This photograph was taken on a farm in Fowlerville, Michigan. It is the reference photograph that I used for color demonstration 11. I thought it would make an interesting subject for a tonal breakdown.

Tone diagrams can also be done with a pencil as shown here. This simplified, but helpful, sketch was drawn on tracing paper with a graphite pencil.

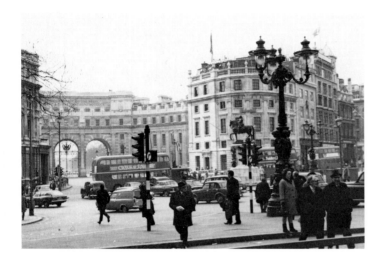

This is another London scene and a good subject for a tone breakdown.

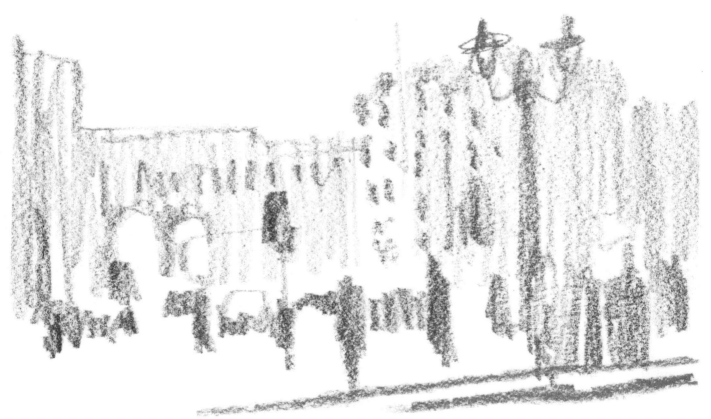

Here is a very simple tone breakdown done on tracing paper with a 4B graphite pencil. This diagram greatly simplifies the subject and is most helpful for the final pencil rendering. These exercises not only help you translate complicated scenes into simple tones, but also help you learn how to see. You can practice these types of diagrams by drawing from photographs in magazines, from your own photographs, or from life. At first, try using only two gray tones and black; then include more tones as you develop. After you get used to doing these sketches with Magic Markers, you can start doing them with pencil. Eventually you will be able to look at an object or scene and visualize the tone values without doing a sketch.

Comparison of Techniques

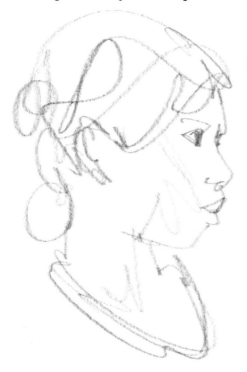

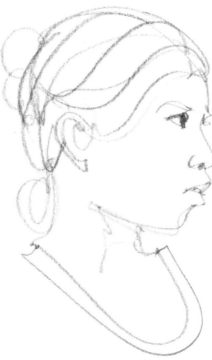

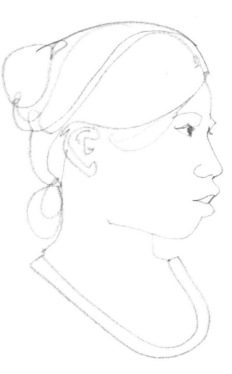

Sketch technique—usually a quick preliminary, undetailed sketch.

Loose line technique—free drawing, but more accurate and detailed than a sketch.

Contour line technique—a more carefully drawn sketch emphasizing contours of subject.

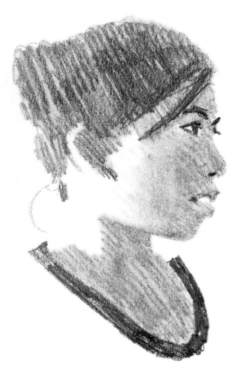

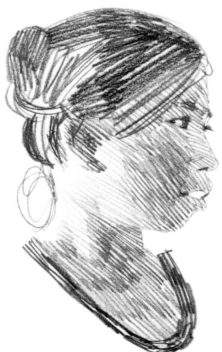

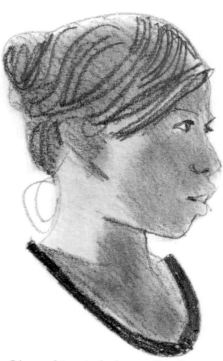

Tone technique—a drawing done in shades of tone or color rather than line.

Line-tone technique—lines drawn closely together to create a tonal value.

Line and tone technique—a line drawing combined with tones.

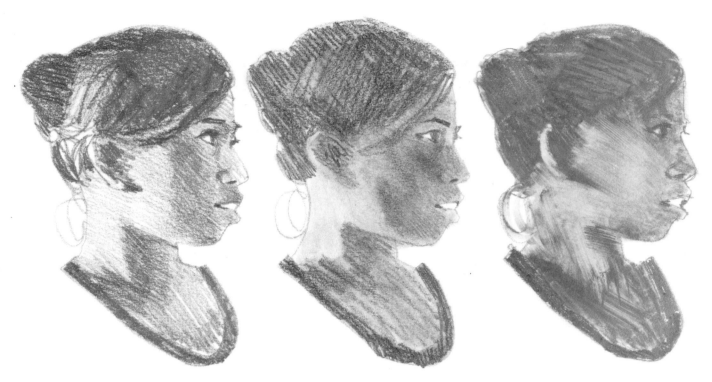

Blended tone technique—two or more gray or color tones blended through rendering.

Smudged tone technique—two or more gray or color tones blended with fingers, a rag, or a rolled paper stump

Dissolved tone technique—tones or lines dissolved with a solvent.

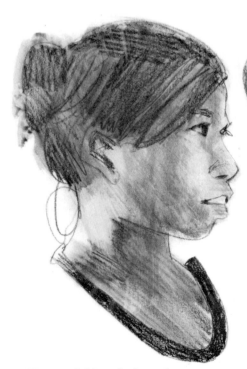

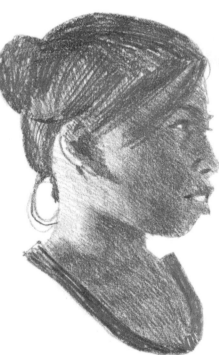

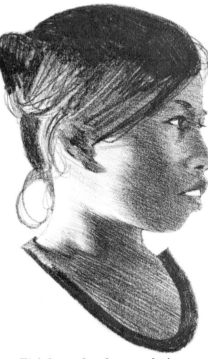

Water-soluble technique—tones or lines dissolved with water.

Rendered tone technique—tones carefully blended and fused through rendering.

Tightly rendered tone technique—a very meticulously rendered drawing that is usually quite photographic.

Chapter Three
Graphite Pencils

The graphite pencil is one of the most commonly used pencils for drawing. Its availability in a wide range of lead grades adds to its usefulness as a fine drawing tool and may account for its popularity.

Graphite pencils can be used in many ways, and numerous examples of possible techniques are illustrated in this section. These techniques can produce varying results, from rough sketches to highly detailed renditions. The drawings have been done on various types of paper with differing textures to demonstrate the variety of work you can do. The various drawing styles range from decorative to hyperrealistic. The techniques cover line, line-tone, line and tone, and dissolved tones. The subject matter includes outdoor scenes, animals, portraits, and figures. Two examples are of the same subject drawn in different techniques for your comparison. One example includes a preliminary sketch, showing how tones in a scene can be translated into simpler tones. Although all the techniques shown may not interest you, it is important for you to be aware of them. Studying the various methods of working and the different rendering techniques will enable you to recognize how a drawing was done.

There are four step-by-step demonstrations included in this section. Each demonstration shows stages in the drawing process so you can see how the drawings were done.

The first demonstration deals with a sketching technique—the use of a paper stump to create and blend tones. The second demonstration shows you how to use flat tones to achieve a decorative effect. The third demonstration uses another tone technique to create a realistic portrait of a woman. The last demonstration covers an interesting technique involving line and line-tone. Using this technique, an artist can create tone with lines.

After studying these demonstrations carefully and reviewing the exercises, you should pick out a simple subject and try one of the techniques. Your drawing can be done from life or from a photograph, if you prefer. If you choose to use a photograph, be sure it is well lit and clear. Otherwise you may have a problem seeing details. I often work from Polaroid photographs, which are rather small. But it is much better to work from larger, 8″ x 10″ (20 x 25 cm) prints when drawing complicated subjects. You can also use good photographs in magazines.

When trying to duplicate the technique here, remember to start with very simple line or sketch techniques and simple subjects. Also keep your drawings small. Then gradually progress to more complicated techniques and subjects and to larger drawings. If you try to advance too quickly or take on a project beyond your capabilities, you will only become discouraged.

PONT NEUF, *9″ x 12½″ (22.8 x 31.8 cm)*. This sketch was done on a slightly textured bristol paper using an HB grade pencil. The various tones were created by first carefully drawing them in and then smudging them with a rolled paper stump. This drawing illustrates a decorative use of tone and demonstrates the tonal range of the HB grade pencil. If I had desired darker tones, I would have used a 2B or 4B grade for these values.

Decorative Tone

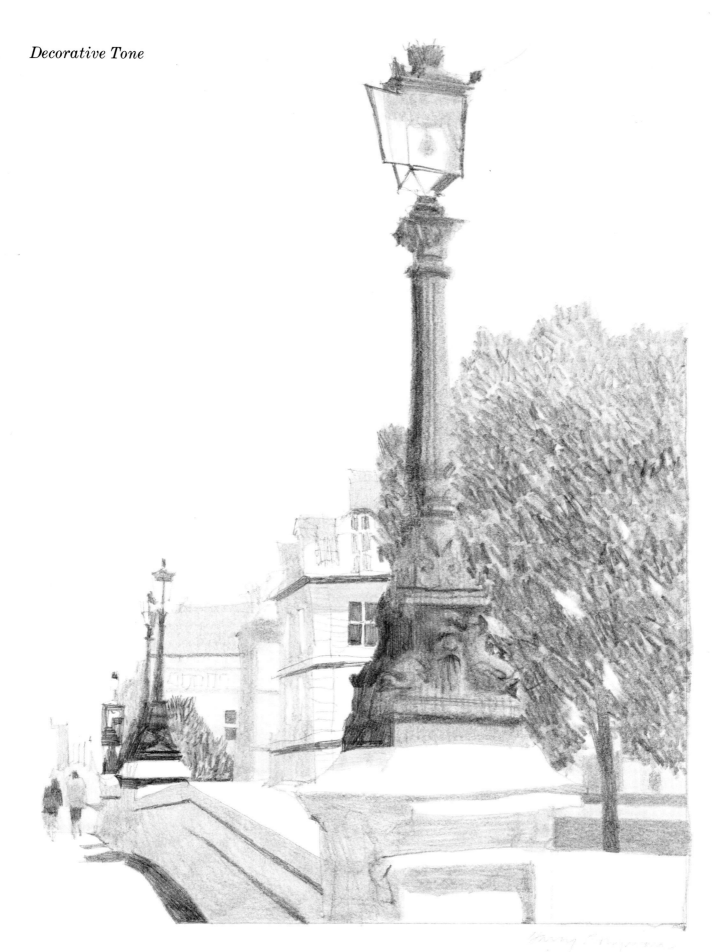

Loose Line with Smudged Tone

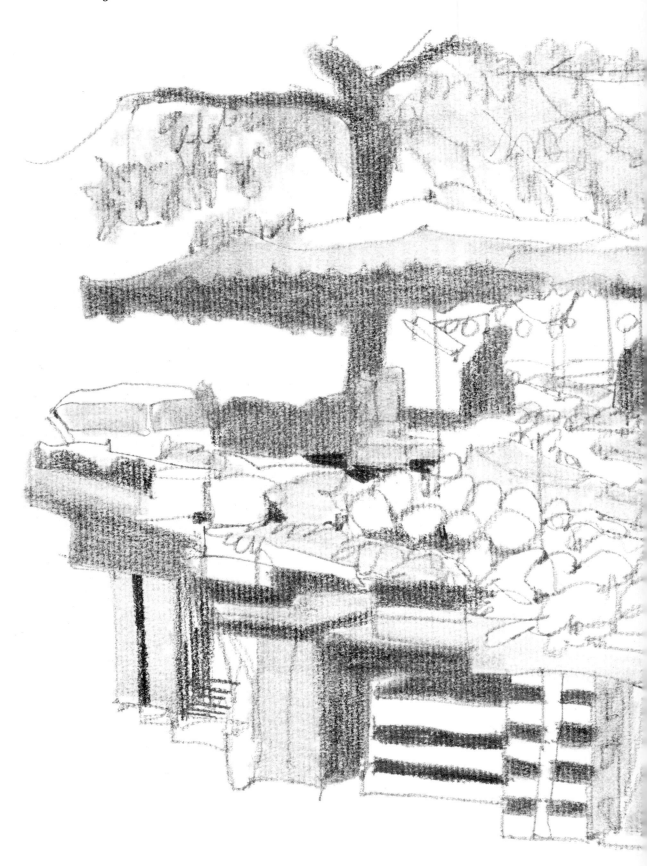

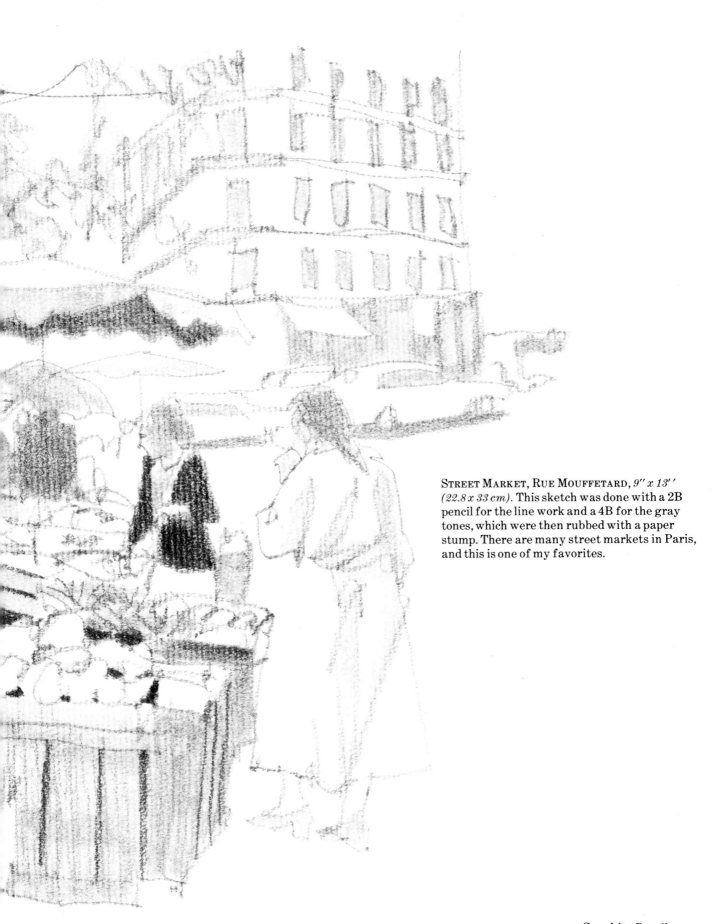

STREET MARKET, RUE MOUFFETARD, *9″ x 13″*
(22.8 x 33 cm). This sketch was done with a 2B
pencil for the line work and a 4B for the gray
tones, which were then rubbed with a paper
stump. There are many street markets in Paris,
and this is one of my favorites.

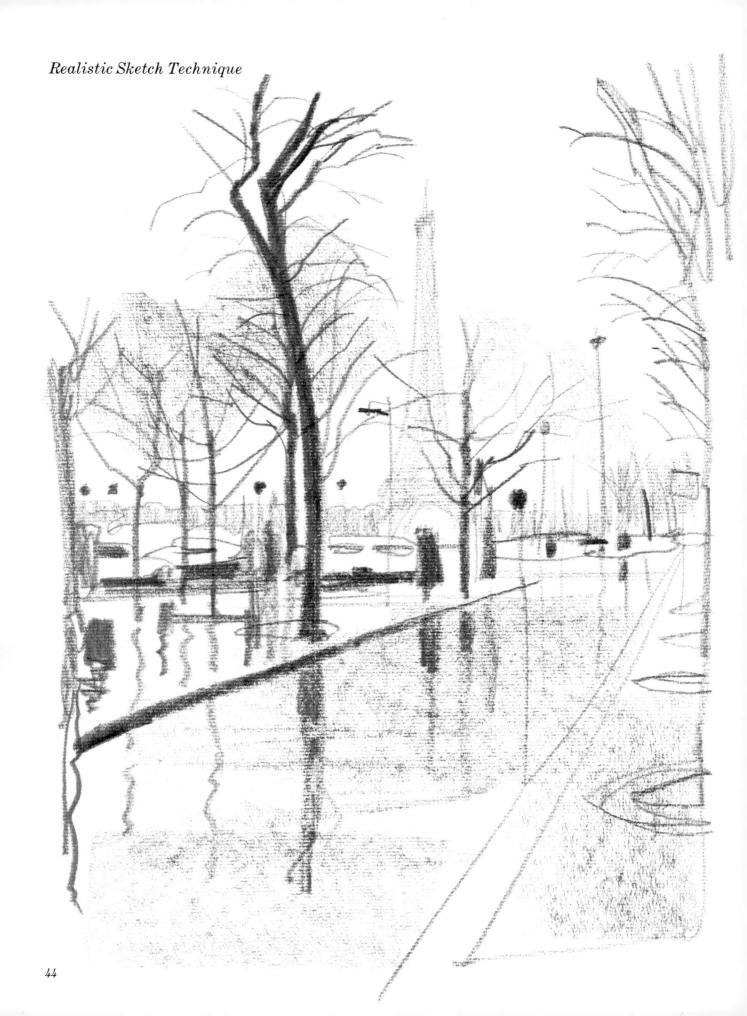

Realistic Line Technique

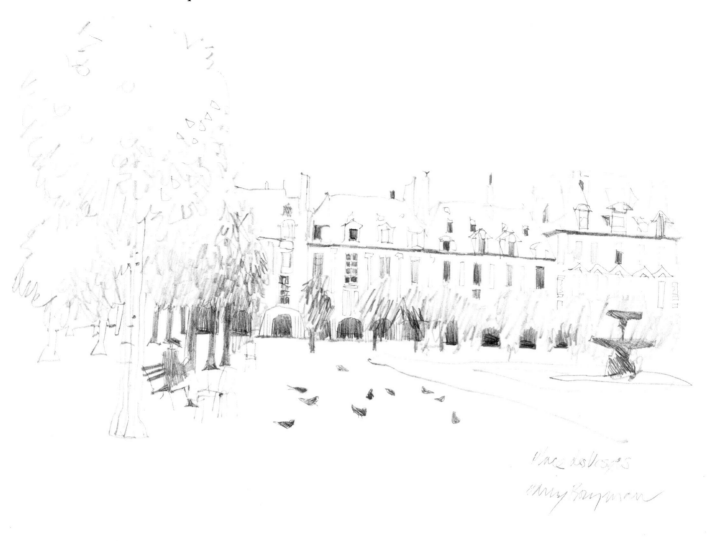

Above. PLACE DES VOSGES, *9″ x 5⅞″ (22.8 x 15 cm).* Another very simple pencil technique, this sketch was done on a smooth paper surface with an HB pencil. Incidentally, Place des Vosges is the oldest square in Paris and is very beautiful. It is now undergoing restoration; don't miss it if you visit Paris.

Left. PLACE DE L'ALMA, *11″ x 15″ (27.9 x 38.1 cm).* This very quick, bold study was drawn with a grade 4B graphite stick on MBM Ingres d'Arches paper. Notice the interesting surface texture of the paper.

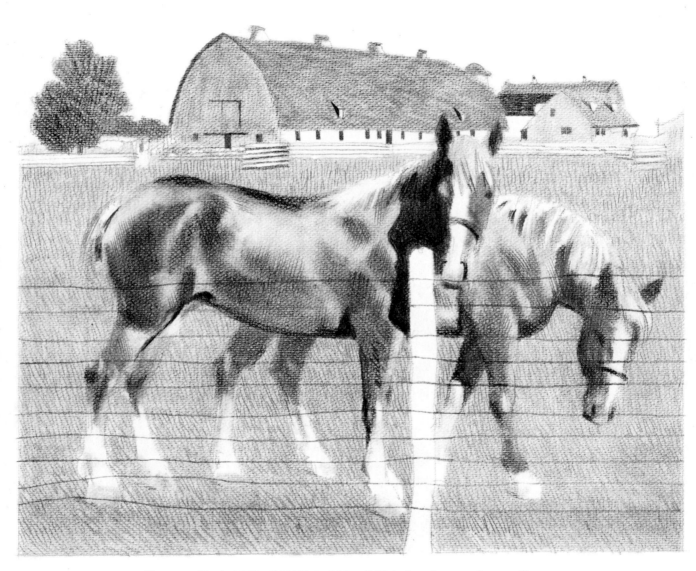

MICHIGAN FARM *11¼″ x 9¼″ (28.6 x 23.5 cm)*. This drawing was done on Canson Montigolfier paper using three different grades of pencils—HB, 4B, and 6B. The soft gray tones were created by rubbing the pencil tones with a paper stump.

OLD FARM HOUSE NEAR LEMANS, FRANCE *12⅝″ x 9⅜″ (32 x 23.8 cm)*. Again, using the HB, 4B, and 6B pencils, I drew this old farm house on Annecy paper made by Aussedet. This is a very nice paper with a slight surface texture.

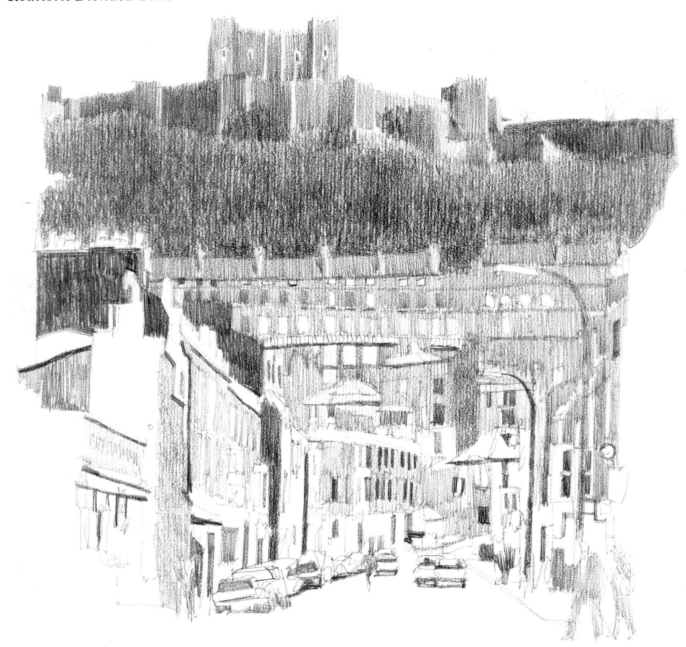

Above. DOVER CASTLE, *10⅝″ x 10½″ (27 x 26.7 cm)*. This drawing demonstrates a more involved technique. It is more finished and incorporates a wider range of tones. It was drawn on Ingres Canson paper with an HB pencil.

Right. QUAI DE BOURBON, *9½″ x 12⅞″ (24.1 x 32.7 cm)*. An HB pencil was used on a very smooth bristol surface. This illustrates a highly detailed, meticulously rendered drawing technique suitable for many subjects. It is a complex technique which you can only master with a great deal of practice. Many of the lighter values were created by erasing some of the pencil tones with a kneaded rubber eraser. A high-surface bristol paper with a smooth surface is best for this type of work.

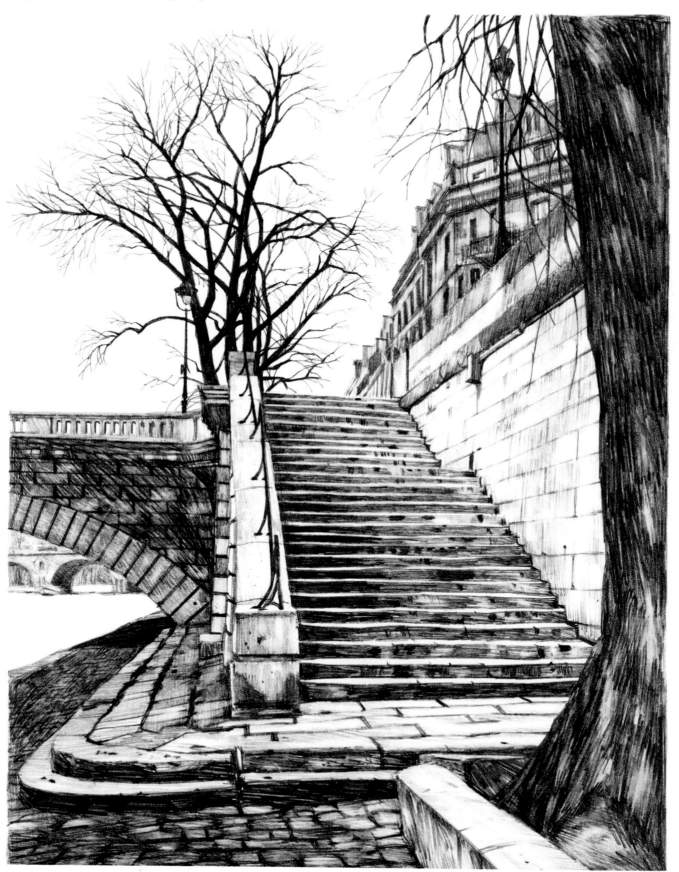

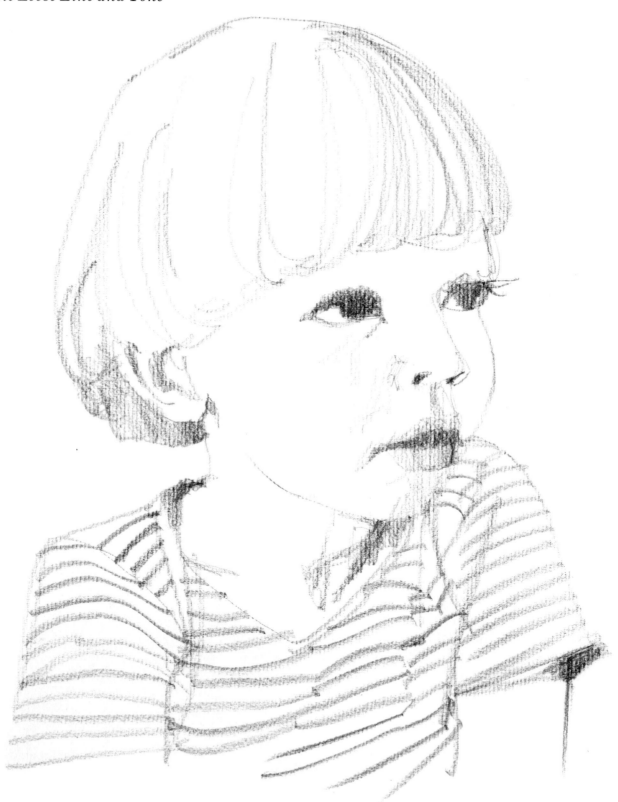

TAVIS, *8⅛″ x 11½″ (20.6 x 29.2 cm)*. This study illustrates a nice, free drawing technique that is perfect for sketching portraits. The few tones which were employed were used to accent the form in the face. An HB pencil was used on Ingres Canson paper.

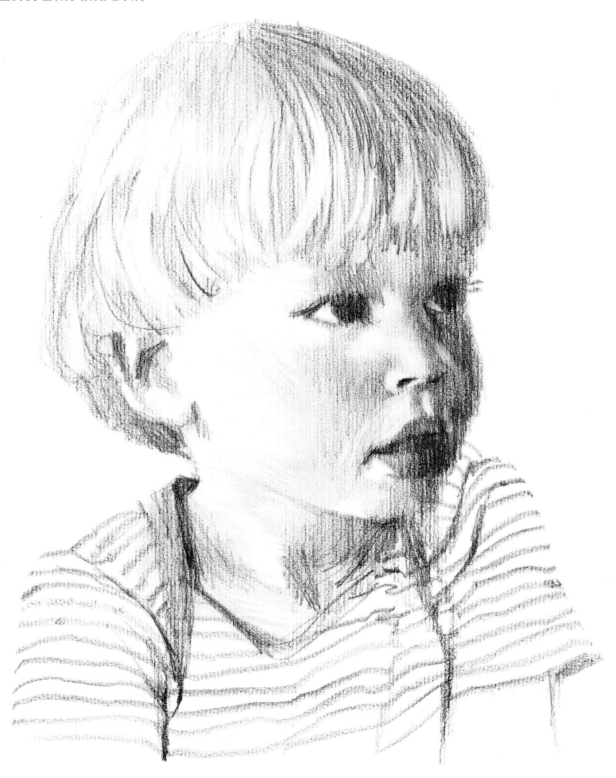

TAVIS, *8⅛″ x 11½″ (20.6 x 29.2 cm).* Same model, same pose, but this time drawn in a different technique. This is a much more detailed version, employing more tones. I smudged the pencil tones with my fingers and picked out the white highlights with a kneaded rubber eraser—a very effective technique for portraiture. This drawing was done from photographs taken of the model.

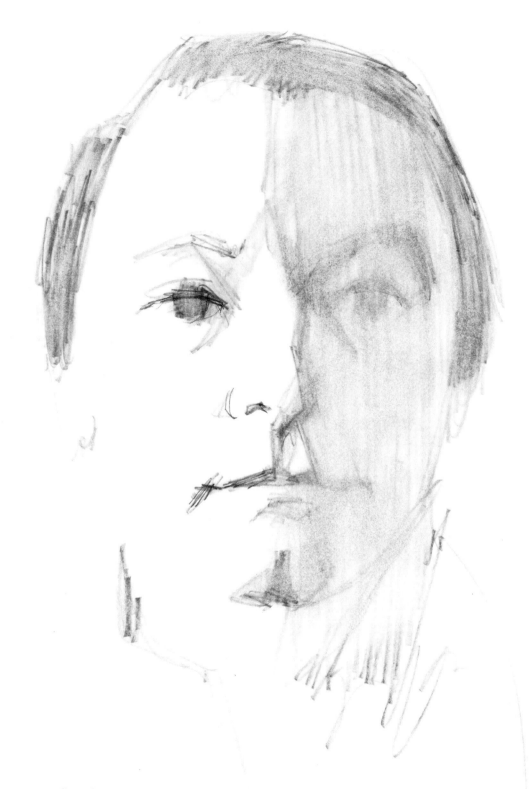

SELF-PORTRAIT, *6½″ x 10⅞″ (16.5 x 27.5 cm)*. If you can't find a model or if you run out of things to draw, you can always draw yourself. But since self-portraits are not particularly easy, you can simplify the process by drawing from a Polaroid photograph. This is a quick study drawn on a very smooth bristol with an HB pencil. The tones were created by dampening a paper towel with a little Bestine and dissolving some of the graphite by rubbing over the pencil lines.

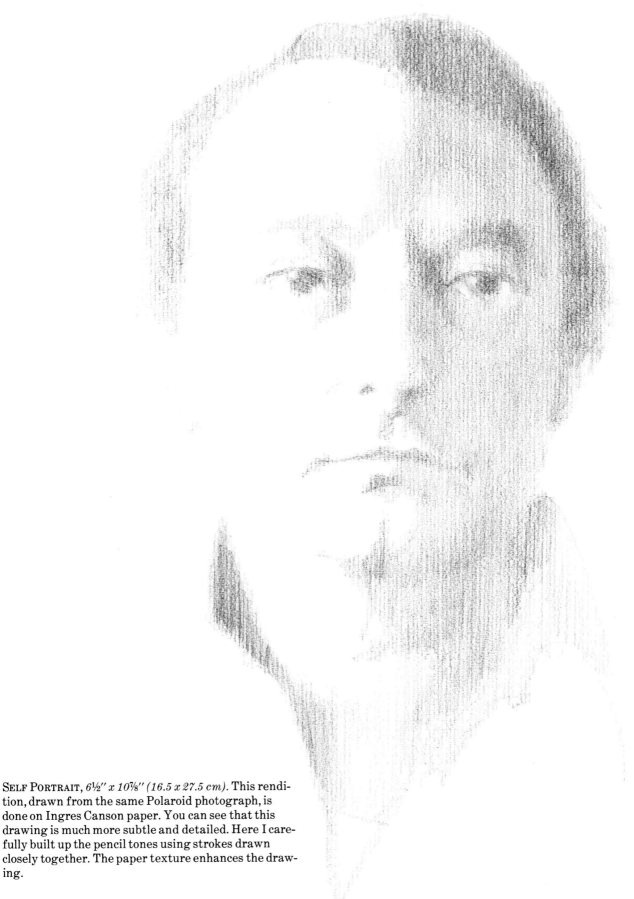

SELF PORTRAIT, *6½″ x 10⅞″ (16.5 x 27.5 cm)*. This rendition, drawn from the same Polaroid photograph, is done on Ingres Canson paper. You can see that this drawing is much more subtle and detailed. Here I carefully built up the pencil tones using strokes drawn closely together. The paper texture enhances the drawing.

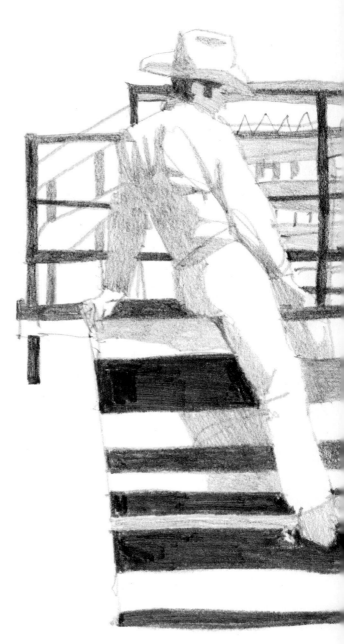

Above. TONAL STUDY FOR A PENCIL DRAWING, *9⅛″ x 6¼″ (23.2 x 25.9 cm).* Often I make a preliminary study like this before starting the actual rendering of a complicated subject. This helps me to establish not only the tonal values but the composition as well. Many problems which can emerge while you are drawing can easily be solved beforehand with this method. I usually do these rough sketches on tracing paper with a soft pencil. Here some of the tones were rubbed with a rag.

Right. Rodeo at Hillsdale, Michigan, *14⅞″ x 9½″ (36 x 24.2 cm).* Done on Annecy paper with HB, 2B, and 6B grade pencils, this drawing conveys a distinctive design feeling. Notice that I have used only very flat, simple tones, without any blending. This adds to the decorative feeling of the drawing.

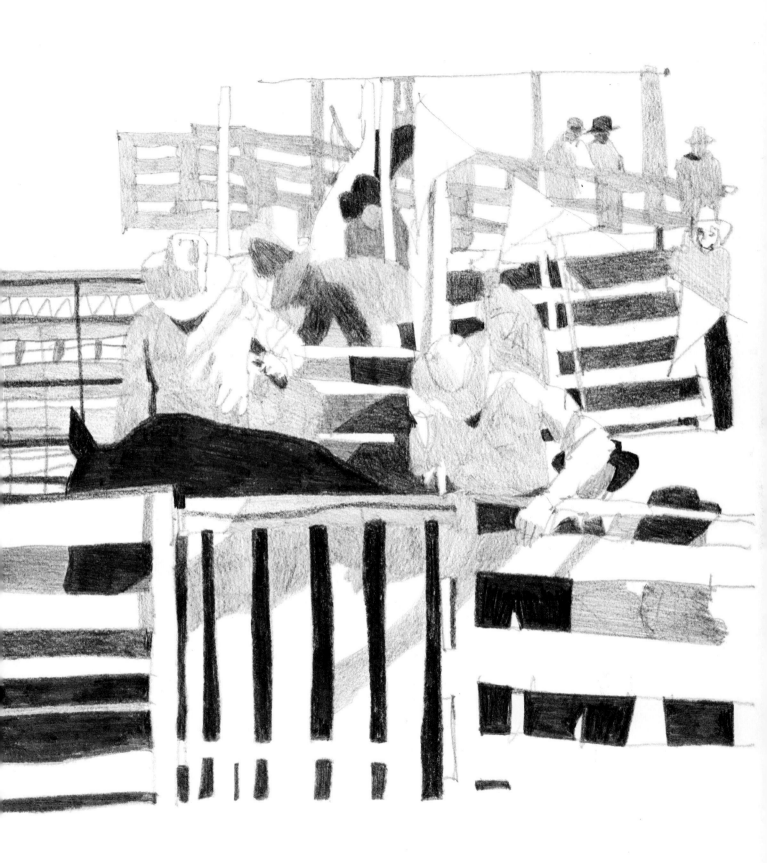

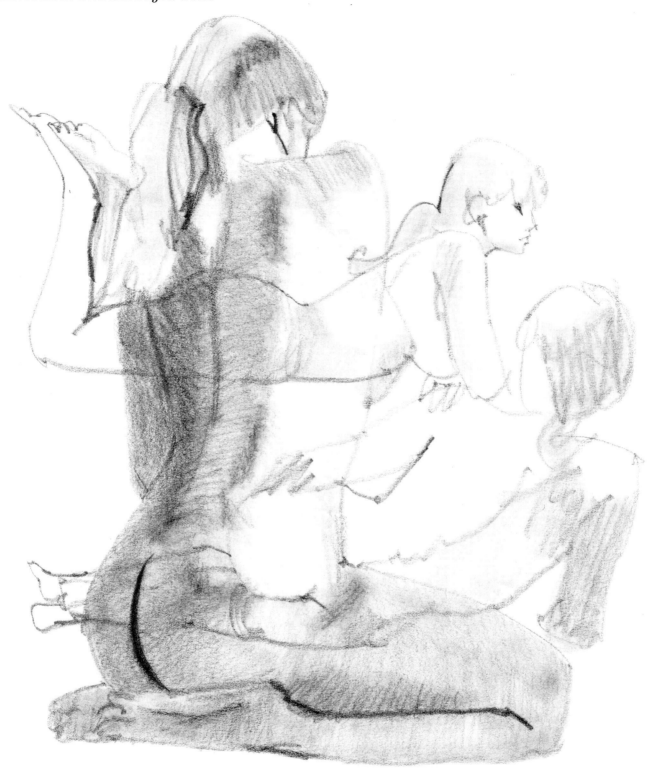

FIGURE STUDIES, *9 13/16″ x 11⅞″ (25 x 30 cm).* A Hardtmuth Cyklop 2040 4B grade graphite stick was used to sketch these figure studies. They were drawn on a smooth-surface bristol, and a paper stump was used to smudge and blend the pencil tones. You don't have to go to a life-drawing class to do a drawing like this. There are books available for artists with photographs of figure studies which can be used for drawing and sketching. The above sketches were drawn from photographs in a book titled *The Fairburn System of Reference*. This reference book contains hundreds of figure photographs of various models in different poses, clothed as well as nude.

Girls from Sanur Beach, Bali, *10¼″ x 11½″ (26 x 29.2 cm).* This sketch was drawn on MBM Ingres d'Arches paper with a Cyklop graphite stick. To achieve the tones, I first drew a series of very closely spaced lines. Then, using a rag dampened with Bestine, I smudged and smoothed out the tones. This is a very effective technique for on-the-spot sketching.

Demonstration 1. Loose Line and Smudged Tone

This demonstration illustrates a simple, effective sketching technique that is ideal for drawing spontaneously outdoors. Be aware that you don't have to cover your paper completely with tones—leave some white paper. It will extend the tonal range of your drawing as well as keep your work looking fresh.

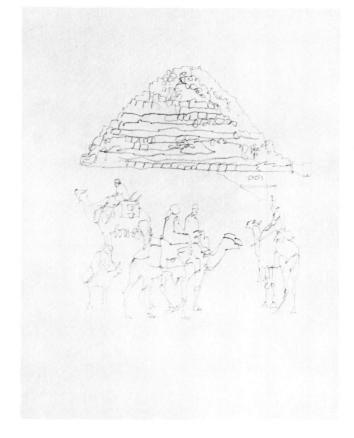

Step 1. I begin by doing a quick, rather loose line sketch with a 2B graphite pencil on a medium-surface bristol board. This paper has a slight surface texture that is well suited for pencil drawings.

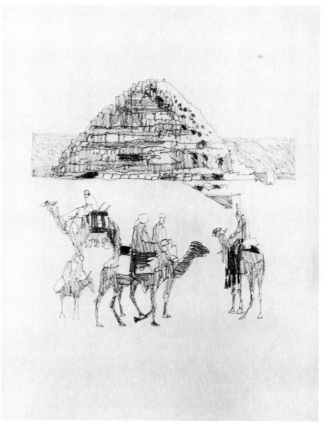

Step 2. I now add various shadow tones and values with a 4B pencil. These are drawn in quite roughly and will be blended later with a paper stump.

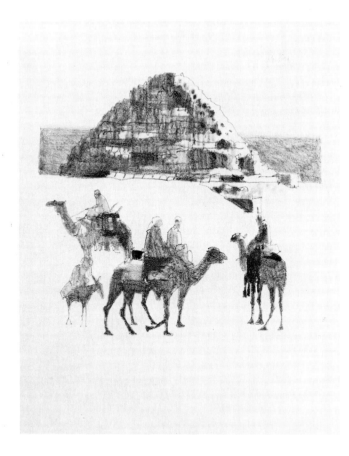

Step 3. Using a paper stump, I smudge the pencil tones until they are blended smoothly.

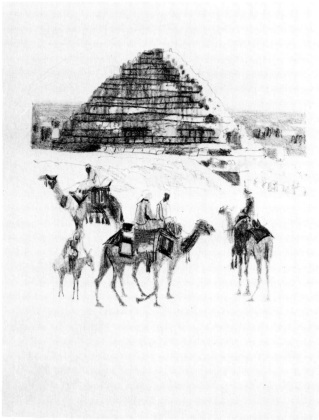

Step 4. Now I add some of the dark details to the camels, riders, and the pyramid in the background. This helps to define some of the shapes better through contrast. I also roughly sketch in the middle-ground rocks, indicate trees in the background, and pick out some of the building shapes with a kneaded rubber eraser.

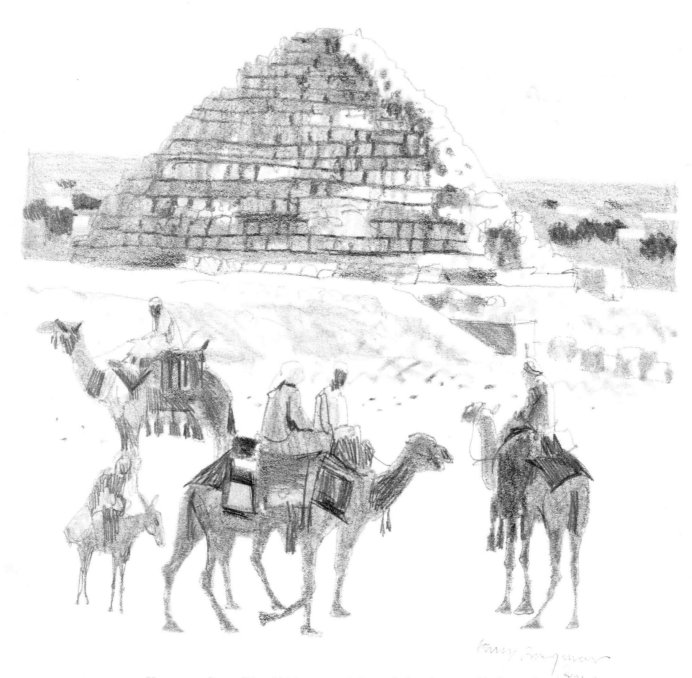

VIEW FROM GIZA, 9⅞″ x 9½″ (25 x 24 cm). I now define the stone blocks on the pyramid as well as darken some areas in the background. With the paper stump, I indicate a little more ground rubble and other textures. I finish the sketch by drawing in cloud shapes with the paper stump. The subject is one of the minor pyramids at Giza. The area is actually on high ground, and Cairo is in the distance.

Demonstration 2. Decorative Line and Smudged Tone

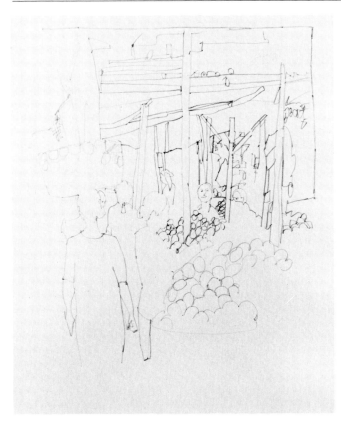

This demonstration involves an approach that is much more design oriented than that in demonstration 1. Here, basically flat tones and shapes are used to create a strong visual design.

Step 1. I first do my basic drawing with an HB pencil on a smooth, high-finish bristol board.

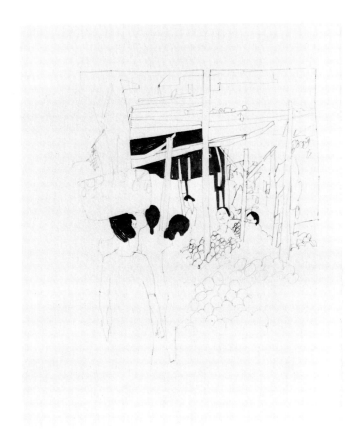

Step 2. Now, with a 4B pencil, I draw in some of the black areas. This helps me establish the middle range of tones in the drawing.

Step 3. I gradually add more of the darker tones, deliberately using pencil strokes that add an interesting texture to the drawing. I use a 4B pencil to draw the darker tones and an HB for the lighter values.

Step 4. Using a paper stump, I darken the skin tones on the figures and then establish the dark tones at the top of the drawing. I also add shadow tones to the foreground fruit by drawing with the paper stump.

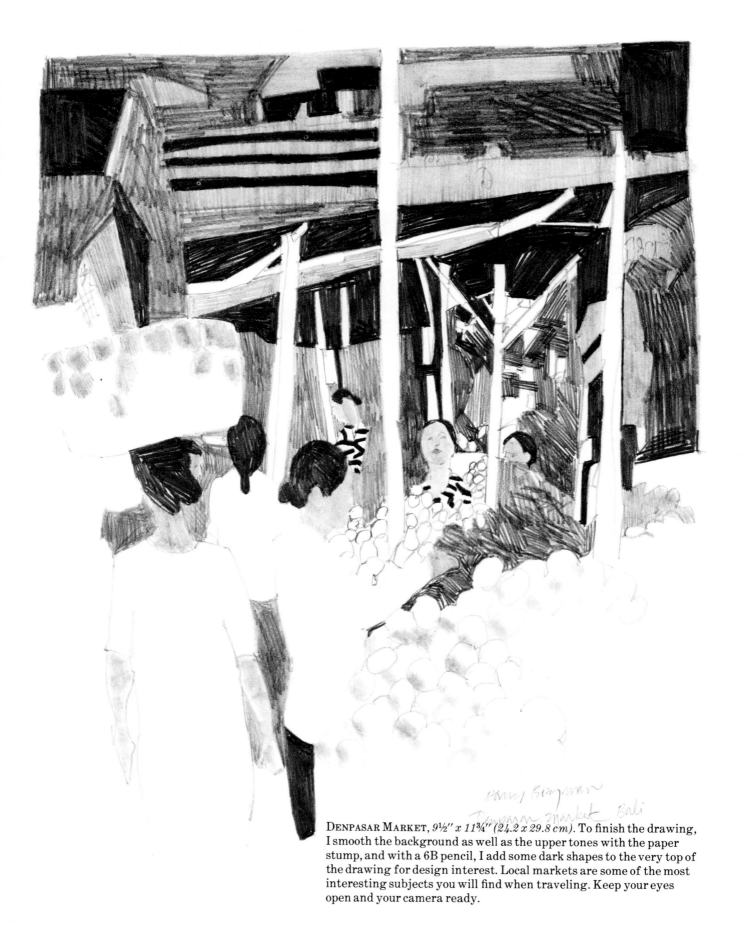

DENPASAR MARKET, *9½" x 11¾" (24.2 x 29.8 cm)*. To finish the drawing, I smooth the background as well as the upper tones with the paper stump, and with a 6B pencil, I add some dark shapes to the very top of the drawing for design interest. Local markets are some of the most interesting subjects you will find when traveling. Keep your eyes open and your camera ready.

Demonstration 3. Smudged Tone

This is a more realistic technique primarily utilizing tone rather than line. It is a useful drawing style suited for portraiture as well as general scenes. The paper used here is MBM Ingres d'Arches, which is perfect for this technique, even though most other papers will also work quite well.

Step 1. Using a Cyklop graphite stick, I do a basic line sketch.

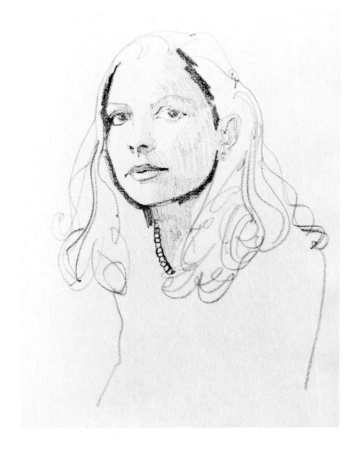

Step 2. I now carefully draw in a few of the facial shadow tones and then begin to put in the very darkest tones.

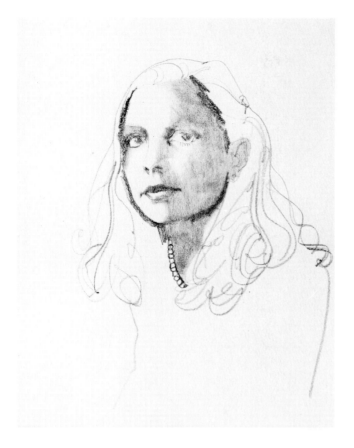

Step 3. Now I carefully smudge and blend the shadow tones with a paper stump.

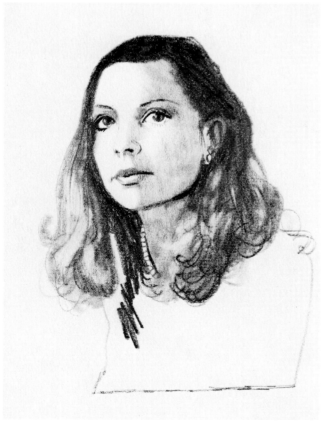

Step 4. I draw in the hair and all of the facial details and start to draw in the dress.

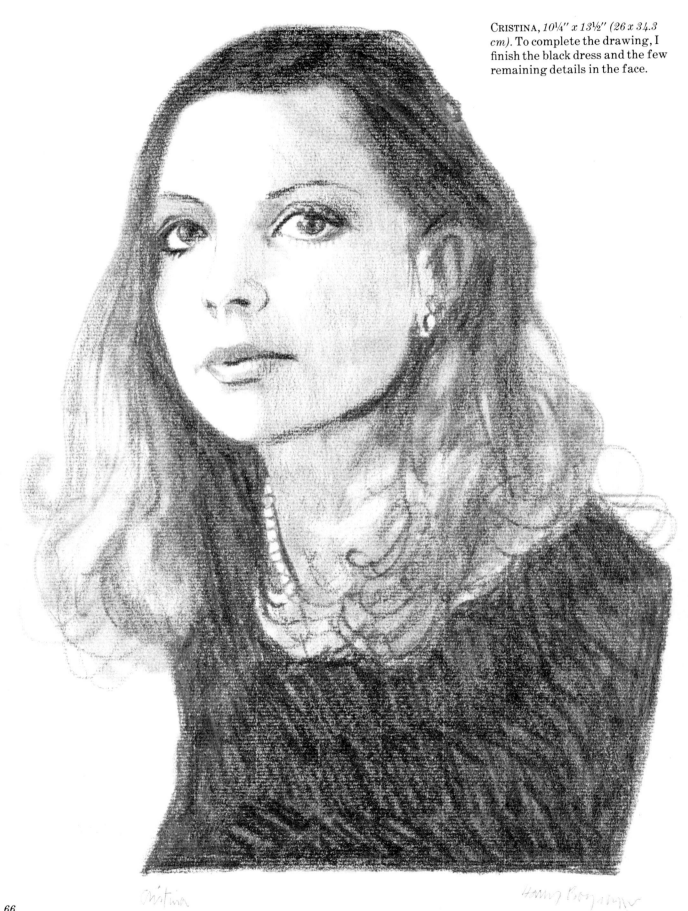

CRISTINA, *10¼″ x 13½″ (26 x 34.3 cm)*. To complete the drawing, I finish the black dress and the few remaining details in the face.

Demonstration 4. Line-Tone

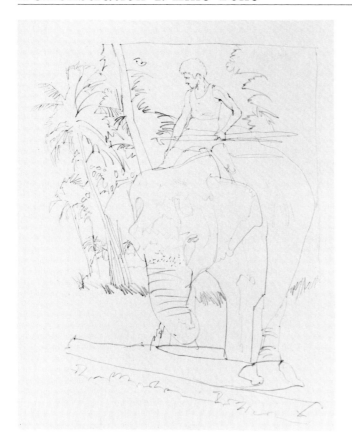

As you have seen in several of the technique examples illustrated in the beginning of this chapter, line can easily be utilized to create tones. Individual pencil strokes, when drawn closely together, fuse visually and give the impression of a tonal value. The density of the tone can be altered by drawing the lines closer together or by simply drawing thicker lines. Even the pressure used can vary the lines, thus changing the tones. This may seem a little difficult at first, but once you see how it is done, you should have no trouble with this technique.

Step 1. This is my basic drawing done in line with an HB pencil on a smooth four-ply Strathmore bristol.

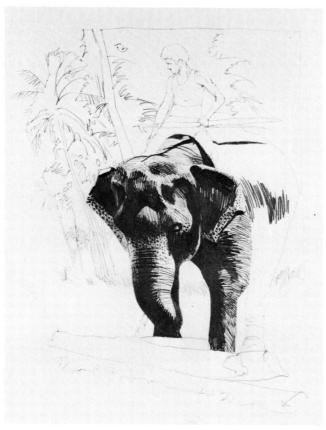

Step 2. I begin to add tones on the elephant using short, linear strokes. As a rule, it is a good idea to follow the form of the object you are drawing because it heightens the illusion of form. In this case, the pencil lines also create a convincing illusion of wrinkles in the skin of the elephant. I now start to add some of the gray tones with a 4B pencil.

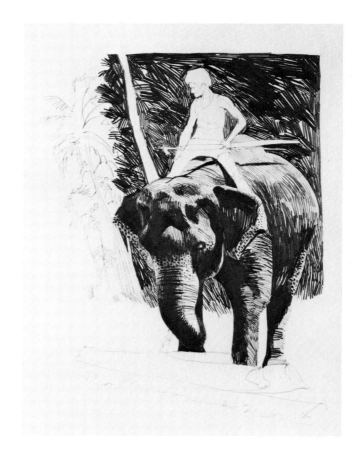

Step 3. I now finish the elephant and sharpen up some of the details and shadow areas. Using the 4B pencil, I then add the dark background strokes. I vary the direction of the strokes to simulate the jungle foliage with the resulting texture.

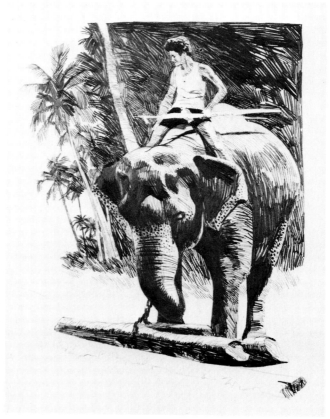

Step 4. I draw in the palm trees and the Mahout, as the driver is called, and cover some of the jungle background with a light pencil tone to subdue the white patches showing through. They seemed a little distracting. Next, I add the logs as well as the shadows on the background tree trunks.

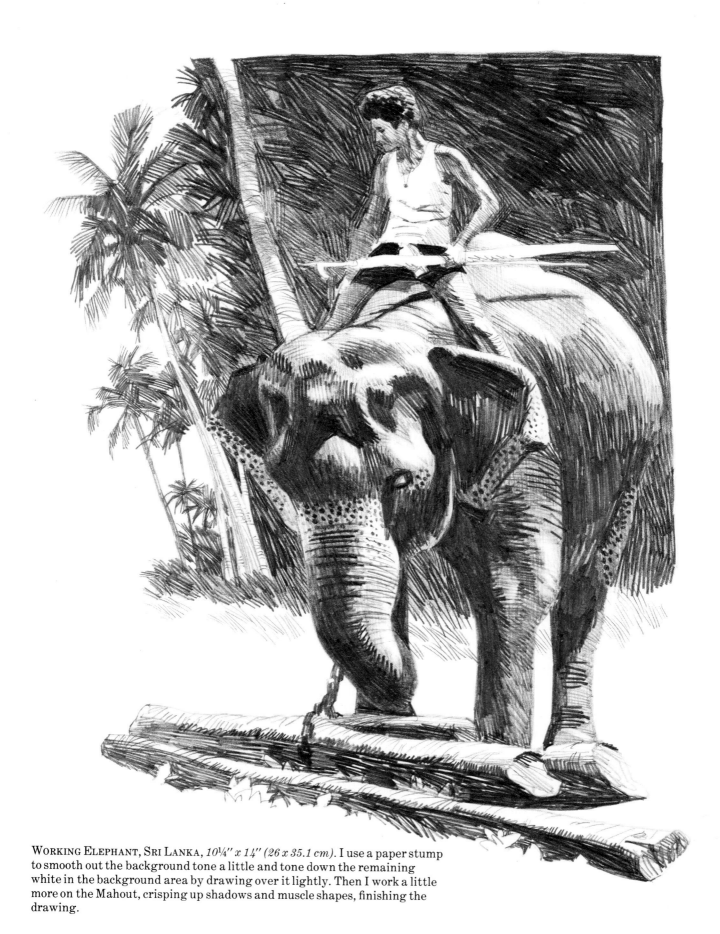

WORKING ELEPHANT, SRI LANKA, *10¼″ x 14″ (26 x 35.1 cm)*. I use a paper stump
to smooth out the background tone a little and tone down the remaining
white in the background area by drawing over it lightly. Then I work a little
more on the Mahout, crisping up shadows and muscle shapes, finishing the
drawing.

Chapter Four
Charcoal, Carbon, and Pastel Pencils

Charcoal pencils are excellent to draw with and have always been a favorite drawing tool of many artists. They are, however, a little more difficult to use than graphite pencils. For one thing, since charcoal pencils are a little more fragile, the leads tend to break easier. Such breakage can ruin your drawings. Another reasons greater care must be exercised with charcoal pencils is that they create more pencil dust. This dust can make your drawings quite messy and dirty. Charcoal pencil points also wear down more quickly than graphite pencils, because the leads are rather soft. Thus frequent sharpening is necessary.

Nevertheless, charcoal pencils have their advantages. They are generally more suitable for tonal work and for covering large areas. They also create a pleasing deep black tone, whereas the black tones of graphite pencils have a little sheen. If you've done the exercises in Chapter Two, you should already be aware of most of these things.

The leads of carbon pencils are similar to those of charcoal pencils, although they are less brittle. Pastel pencils, however, have very soft leads that break easily. Still, pastel pencils are quite nice to work with and have the advantage of being available in a variety of colors.

All of the pencils discussed must be used with care to avoid smudged drawings. One way to prevent smudging is to place a piece of tracing paper under your hand while working with these pencils.

As in the previous chapter, I will present many examples of drawing techniques, which should be examined carefully. The examples include such techniques as line, line and tone, loose line and tone, and line and line-tone. A range of viewpoints, from decorative to realistic, will also be covered. The subject matter includes animals, buildings, outdoor scenes, and still lifes. I have also drawn one scene in two techniques for comparison.

There are three step-by-step demonstrations in this section. They cover the use of charcoal pencil, charcoal stick, and black-and-white pastel pencils on colored paper. The first demonstration, which shows a scene involving an animal, is done with a smudged-tone technique. The second demonstration shows a scene with buildings. It is also done with the smudged-tone technique. The last demonstration illustrate the use of a line-tone technique on colored paper. It is done with black-and-white pencils. A portrait has been used for this demonstration to show you a simple but very effective portrait technique for drawing. I suggest you study all the examples and step-by-step demonstrations carefully, so you will fully understand how the drawings were done. Then pick out a simple subject and try to duplicate the techniques that most interest you. Such techniques should also be tried on various paper surfaces so you can get an idea of the variety of effects possible. Be careful about the pencil dust I mentioned earlier and try to keep your drawings clean. Carefully blow the pencil residue off the paper. This will get rid of most of it. You can clean off the remaining dust with a kneaded rubber eraser.

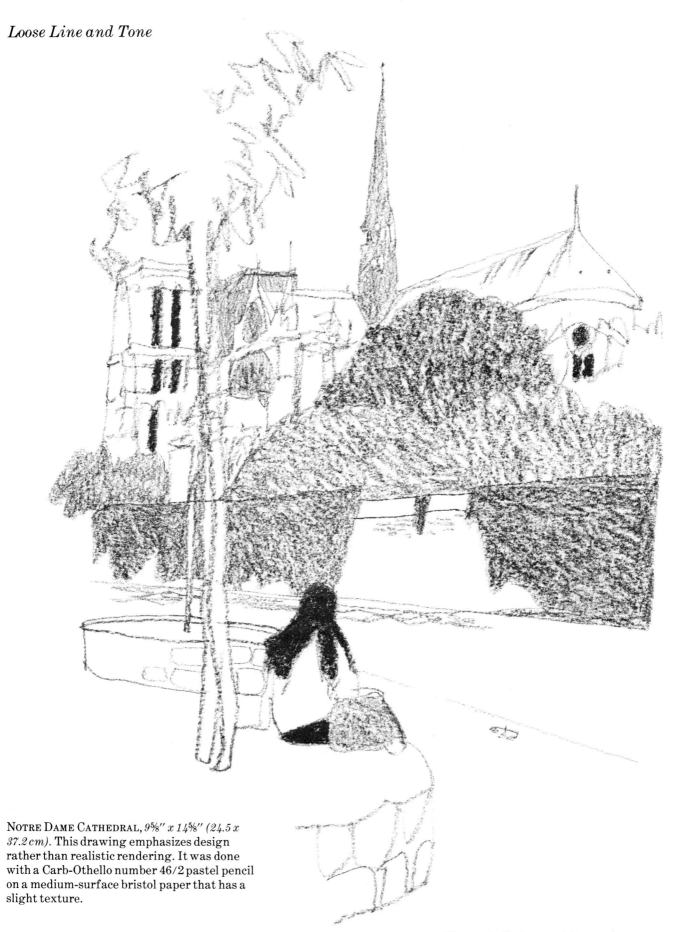

Notre Dame Cathedral, *9⅝″ x 14⅝″ (24.5 x 37.2 cm)*. This drawing emphasizes design rather than realistic rendering. It was done with a Carb-Othello number 46/2 pastel pencil on a medium-surface bristol paper that has a slight texture.

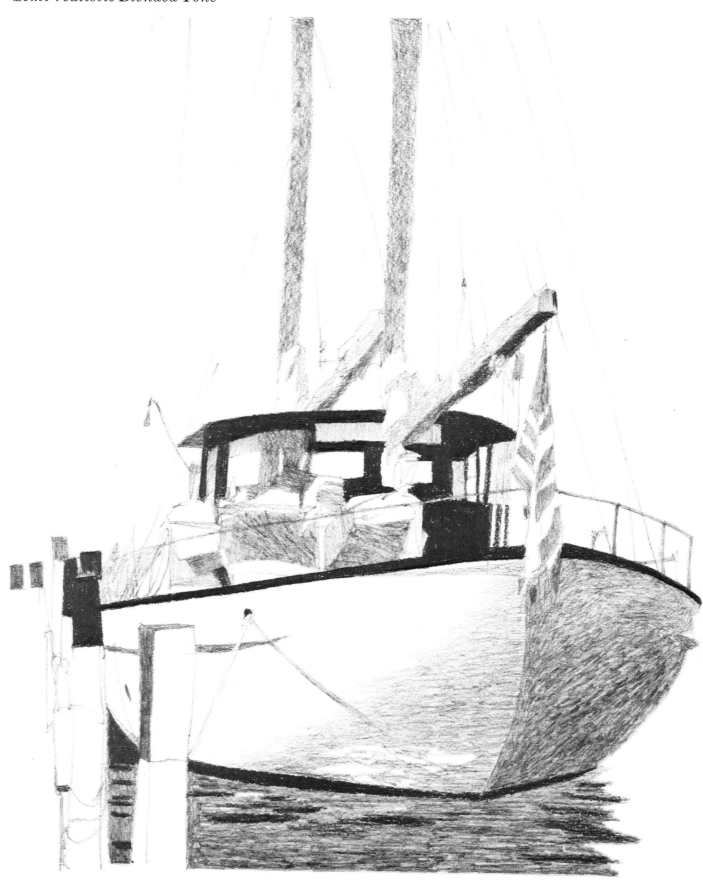

Realistic Line with Black Accents

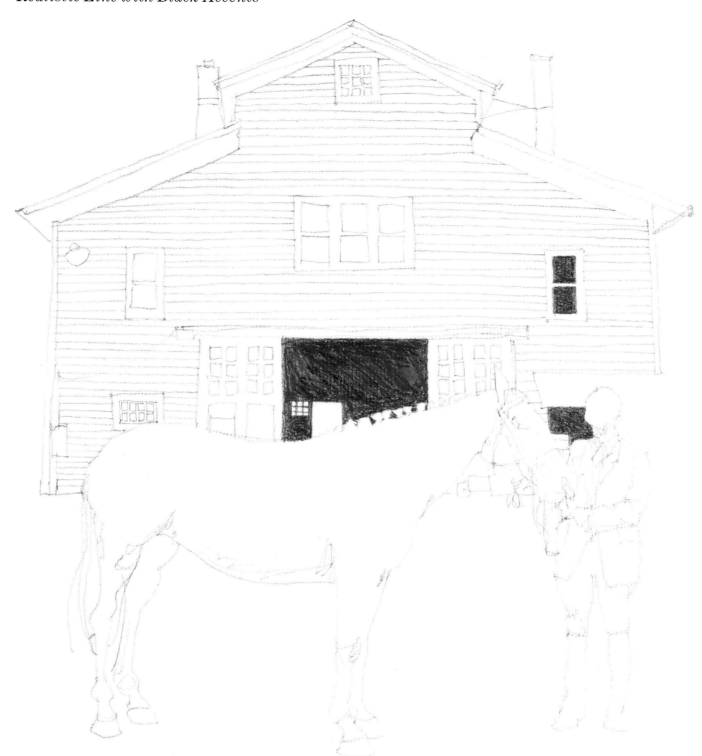

Left. Sailboat, Lake St. Clair, *9⅞" x 12⅝" (25 x 32.1 cm).* This is basically the same kind of drawing as the previous example except for the addition of a few intermediate grays. It was done on a slightly textured bristol paper using an HB grade General charcoal pencil for the outline drawing and a 2B and a 4B grade pencil for the tones.

Above. At the Hunt Club, *10⅜" x 11⅝" (26.4 x 29.5 cm).* Here is a carefully done line drawing with strategically placed black accents that help create very interesting contrast. This example was drawn with a General charcoal pencil number 557, HB grade. It is important for you to master this kind of a line drawing, as it can be the basic drawing for a number of other techniques where tone is to be added.

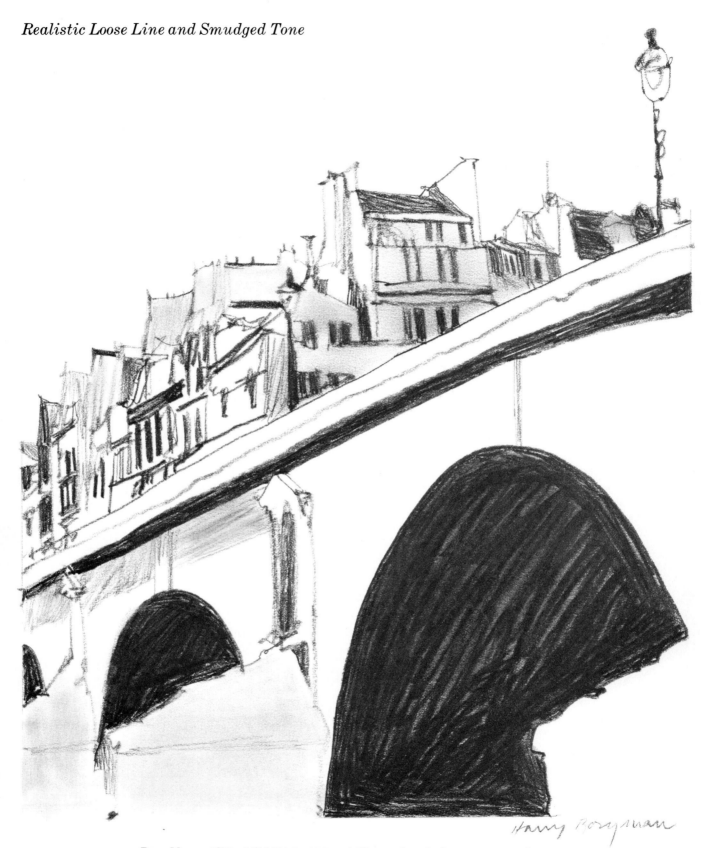

PONT MARIE, *9⅜″ x 11⅜″ (23.8 x 28.9 cm)*. Charcoal works best on textured paper surfaces, but it can also work well on certain smooth papers. This sketch was drawn on a smooth-surface bristol with a 2B charcoal pencil. The gray tones were created by rubbing some of the pencil tones with my fingers.

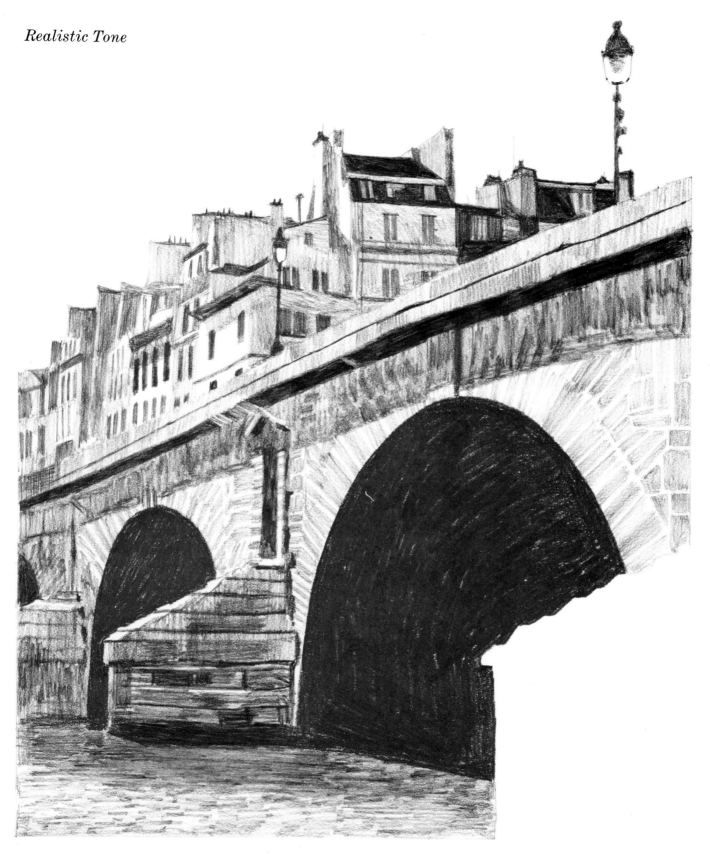

PONT MARIE, *9½" x 11¼" (24 x 30 cm)*. This version of the same subject as the previous example was also done with a 2B charcoal pencil on a very smooth bristol surface. However, this drawing is much more detailed and realistic than the other version.

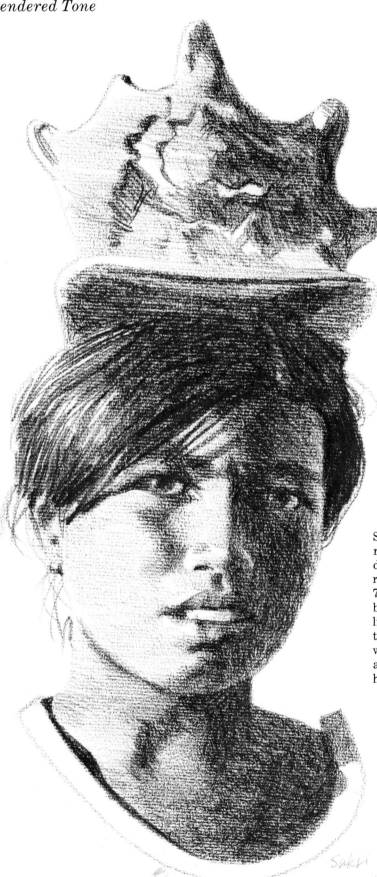

SUKRI, *6¼″ x 14¾″ (15.9 x 37.5 cm)*. This realistic portrait of a Balinese girl was done on a textured paper—MBM Ingres d'Arches—with a Conté à Paris 728B charcoal pencil. I began, as usual, by first doing my basic drawing in light outline. Then I carefully built up the intermediate gray tones. This girl was selling shells on the beach in Bali, and she always carried a large shell on her head.

Realistic Smudged Tone

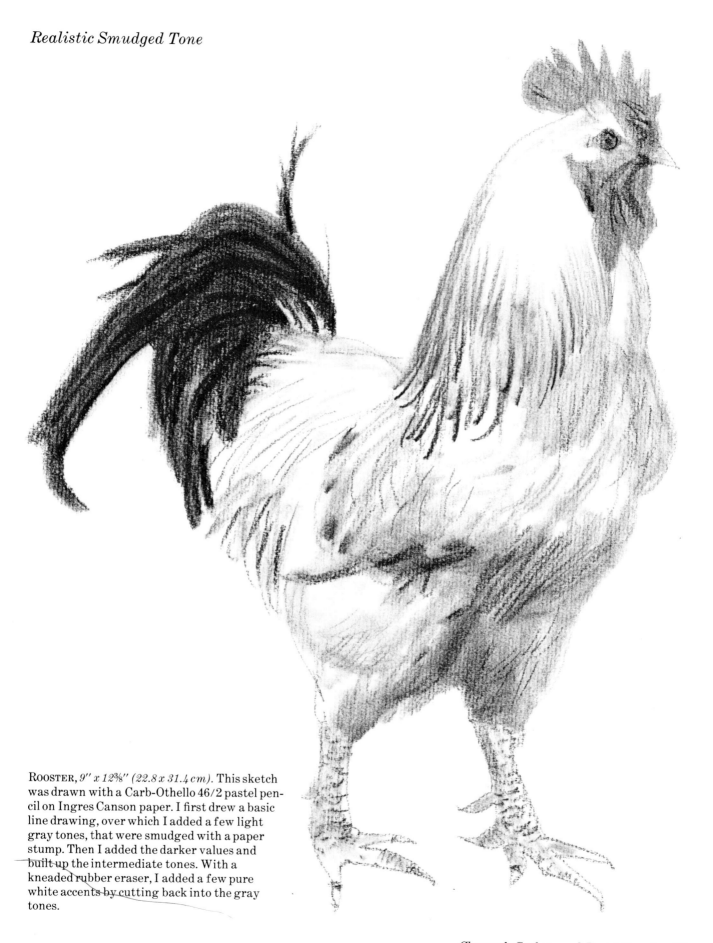

ROOSTER, *9" x 12⅜" (22.8 x 31.4 cm).* This sketch was drawn with a Carb-Othello 46/2 pastel pencil on Ingres Canson paper. I first drew a basic line drawing, over which I added a few light gray tones, that were smudged with a paper stump. Then I added the darker values and built up the intermediate tones. With a kneaded rubber eraser, I added a few pure white accents by cutting back into the gray tones.

Decorative Smudged Tone

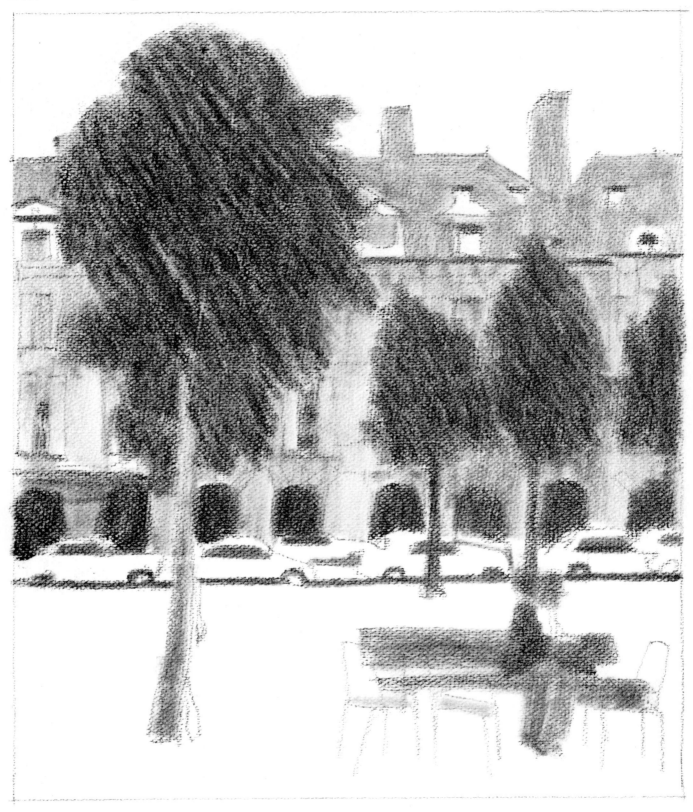

PLACE DES VOSGES *9½″ x 11½″ (24.2 x 29.2 cm).* This tonal sketch was drawn on Canson Montigolfier paper with a Carb-Othello 46/2 pastel pencil. The tones were smudged with a rolled paper stump.

Decorative Smudged Tone

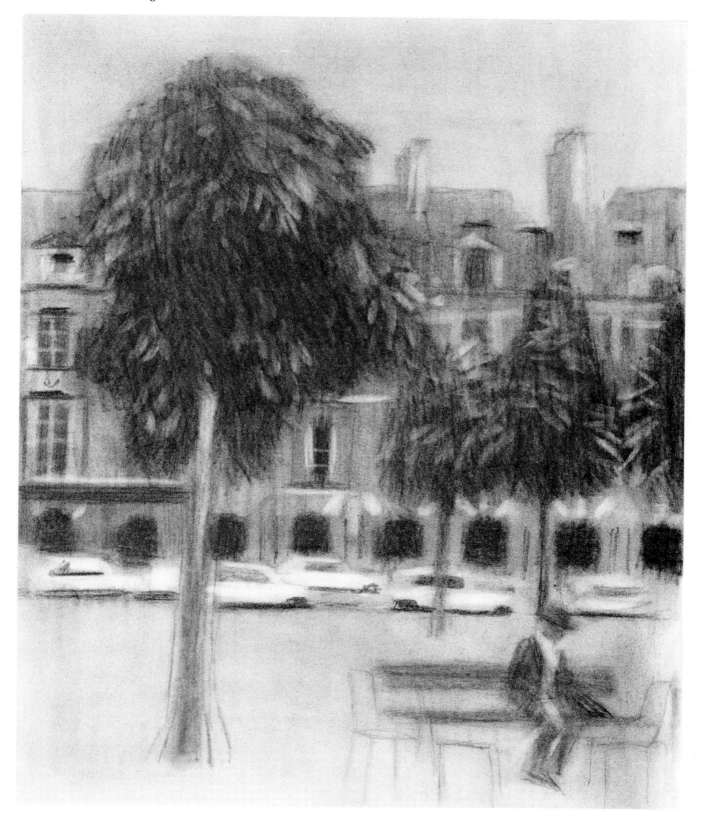

PLACE DES VOSGES, *9½″ x 11½″ (24.2 x 29.2 cm).* As in the previous drawing, a Carb-Othello pastel pencil was used, but this time on a smooth paper surface. The pencil tones were smudged with my fingers, a paper towel, and a paper stump. The highlights were created with a kneaded rubber eraser by lifting out some of the darker tones.

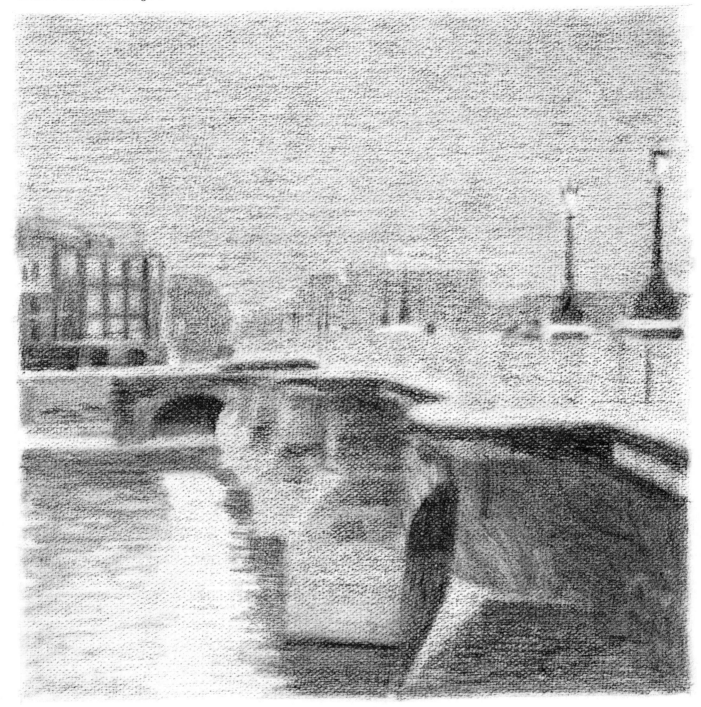

PONT NEUF, *9⅞″ x 12⅝″ (25.1 x 32.1 cm)*. Drawn on Canson Montigolfier paper with a 4B charcoal pencil, this study utilizes only tonal values with no lines. Some of the tones were darkened by finger smudging.

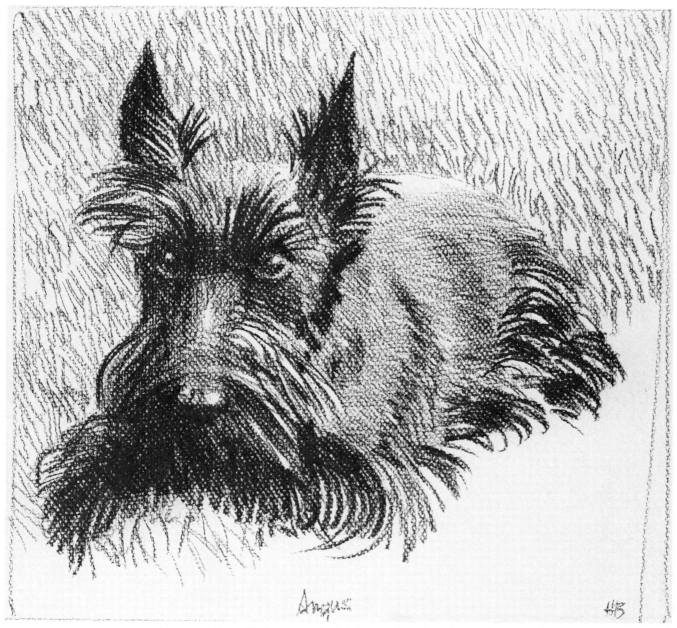

ANGUS, *11½″ x 11⅞″ (29 x 30 cm)*. This is one of my favorite subjects, my dog Angus. With a Carb-Othello pastel pencil on a colored paper, I used only lines to create the various tones. The pencil strokes add to the illusion of the grass and fur textures.

Demonstration 5. Smudged Tone with Charcoal

Charcoal pencil is a flexible medium compatible with a great number of paper surfaces. However, I personally feel that it works best with textured surfaces because texture enhances the charcoal effects.

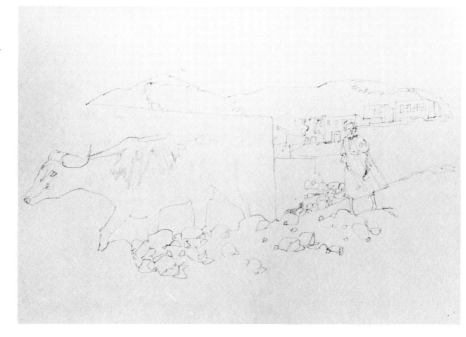

Step 1. The basic drawing is done on MBM Ingres d'Arches paper, using an HB grade charcoal pencil.

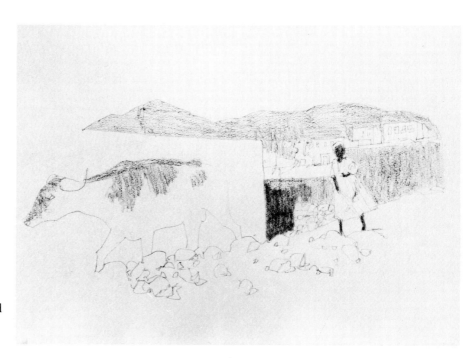

Step 2. I carefully add a few tones and begin to blend them with a paper stump.

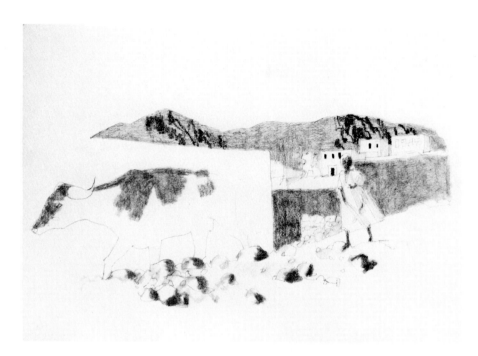

Step 3. I continue smudging the tones and even draw with the paper stump, adding some form to the rocks. I now add a few black tones to the background hills.

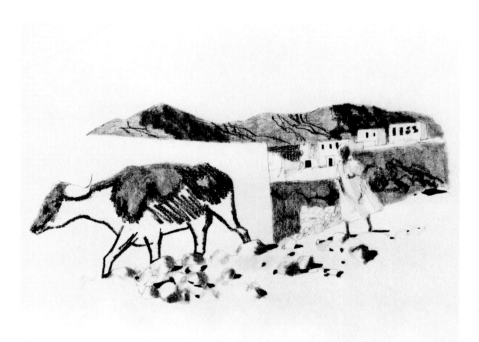

Step 4. I smudge the hill tones with the paper stump and add black shadows under the rocks. I also begin to draw some black tones on the bull.

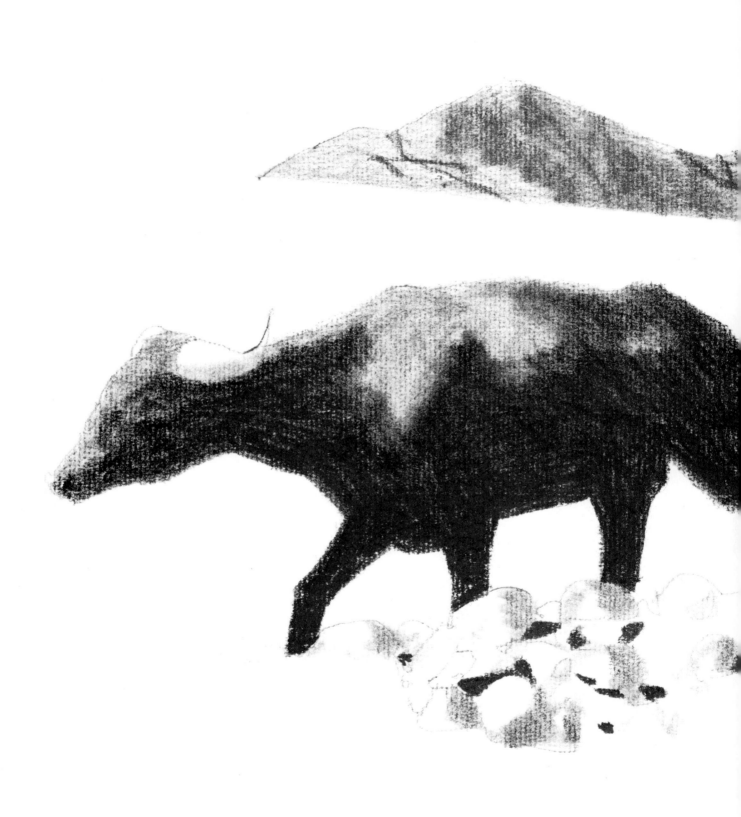

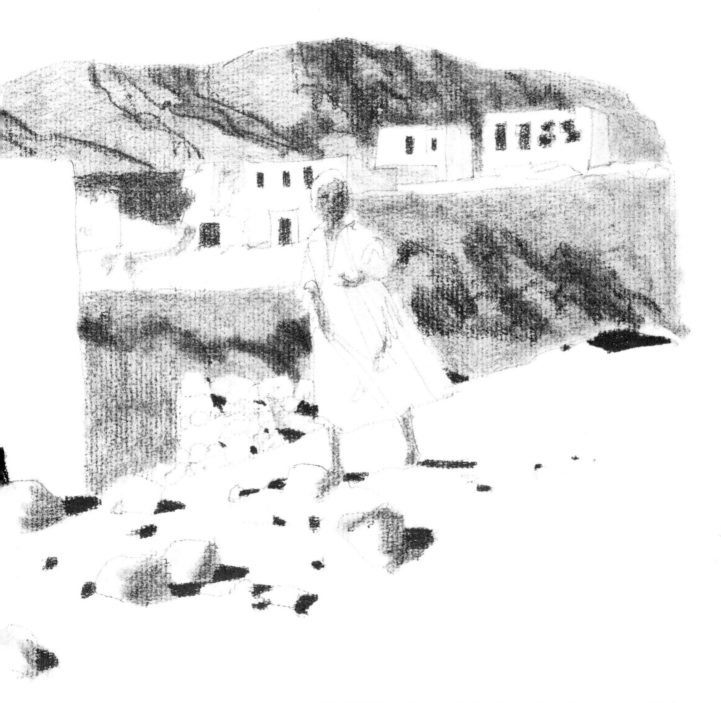

LUXOR, *16" x 7¾" (40.7 x 19.7 cm).* I finish the bull, blending the tones with the paper stump. Then I soften the rock area behind the boy by rubbing it with the paper stump. With few finishing touches I finish the drawing.

Demonstration 6. Realistic Smudged Tone

With a minimum of lines you can produce a drawing composed entirely of tones. This is a good technique for a great many subjects, especially when you want to capture a mood.

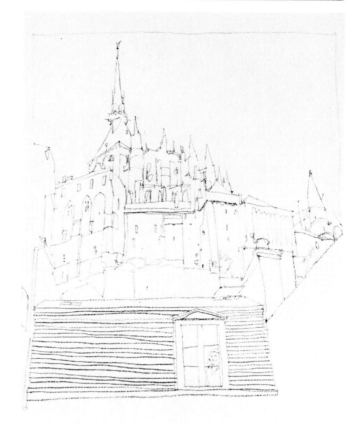

Step 1. I first sharpen a 2B charcoal pencil with an X-acto knife. Then, with a sanding block, I shape the lead to a nice fine point. I begin my drawing by doing a very careful line rendition of the subject.

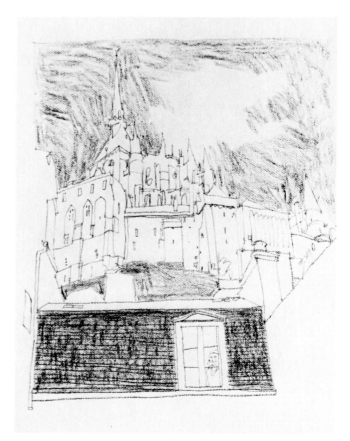

Step 2. I add a few basic tones with a charcoal stick, which I use here, rather than the pencil, because I can cover a larger area more rapidly.

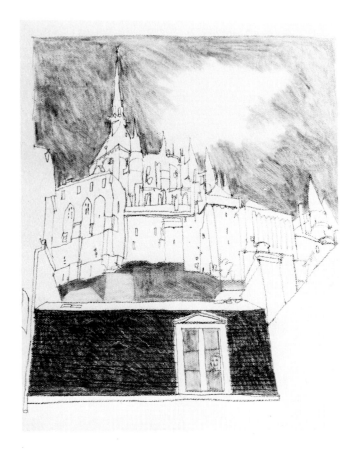

Step 3. Since I am trying to achieve an interesting texture here, I use a paper stump to smudge these tones without attempting to smooth them completely.

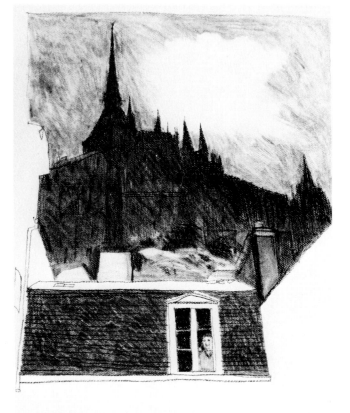

Step 4. I now add a dark tone over the background buildings, using the charcoal stick. I smooth this tone by rubbing it with a rag. Then, using a kneaded eraser, I work on the cloud shape, trying to create a feeling of movement to this area. I also erase sections of the ground just above the foreground roof. You can learn to draw with this unique eraser, as it can easily be shaped into different forms.

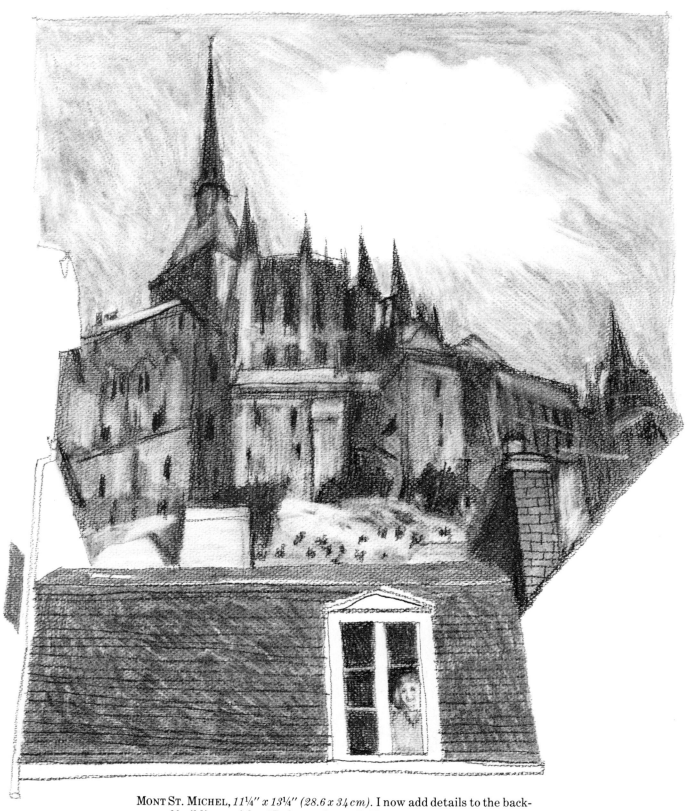

MONT ST. MICHEL, *11¼″ x 13¼″ (28.6 x 34 cm)*. I now add details to the background buildings with a 2B charcoal pencil. Then I pick out more highlights with the kneaded rubber eraser and indicate some foliage on the hill. I finish the drawing by putting in the brick texture on the chimney and adding tone to the foreground roof.

Demonstration 7. Realistic Line-Tone on Colored Paper

This simple but very interesting technique combines both black and white pencils on colored paper, which enables you to achieve some striking effects.

Step 1. Using a black pastel pencil, I indicate the hair shape, eyes, mouth, and dress pattern. Then, using a white Carb-Othello pastel pencil, I carefully indicate the highlight areas on the girl's face.

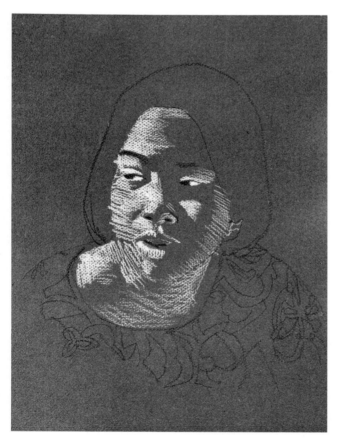

Step 2. Using linear strokes, I draw in the sunlit parts of the face with the white pencil.

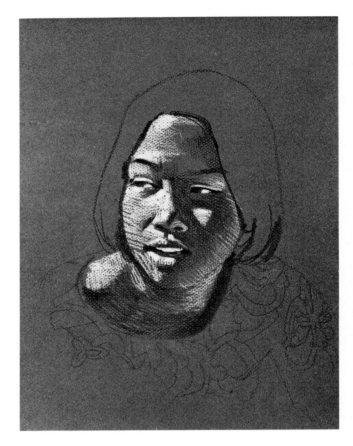

Step 3. Next I model the shadows with the black pencil and then draw in the strongest highlight accents on the face.

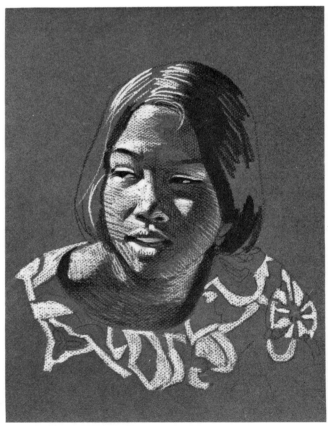

Step 4. With the white pencil, I now add some highlights to the hair and fill in the dress pattern. Then I start to add black to the girl's hair.

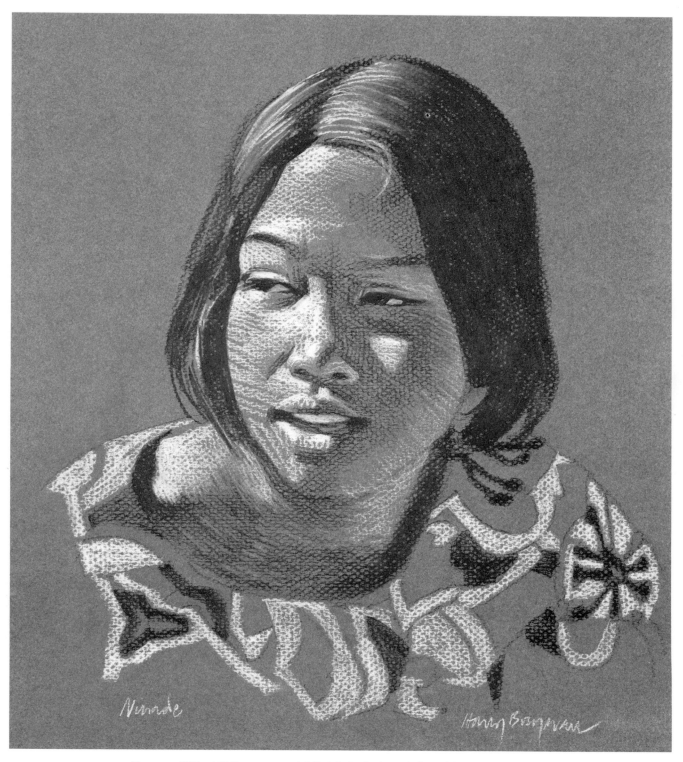

NIMADE, *9¾″ x 11″ (24.8 x 28 cm)*. I finish the hair and also add the black to the dress. To complete the portrait, I sharpen up a few small details such as the eyes and the mouth with the black pencil.

Chapter Five
Wax Pencils

The term *wax pencil* describes a wide variety of both black and colored pencils with wax-like leads. Some pencils in this category are available in degrees of hardness, but most come in only one grade. Black wax-type pencils are generally good for drawing jet-black tones, something difficult to do with most graphite pencils. A good brand is the Koh-i-noor Hardtmuth Negro pencil. These pencils are, however, difficult to erase, so plan your drawings carefully. Most wax pencils work best on very smooth paper, although they are not limited to these surfaces.

The examples presented in this chapter illustrate a sketching technique, line and tone, tone, line-tone drawing on colored paper, and a water-soluble technique. Because Conté crayons are related to wax pencils, I have included them in this section, along with illustrated examples of their uses. All the drawings are done on a variety of paper surfaces, and the subject matter includes portraits, animals, figures, outdoor scenes and a still life. In one case I have drawn the same subject twice, using two techniques. The first example is drawn on a white, textured paper; the other is done on a colored paper, using both black and white pencils. The portrait of the boy on page 102 is another version of the portrait shown on pages 50 and 51. If you compare the drawings, you will see how a subject can be drawn in three ways.

Following the examples of techniques are two step-by-step demonstrations. One demonstration deals with the use of a water-soluble pencil technique. The other illustrates a tightly rendered tone technique done on a smooth-surfaced bristol with the Hardtmuth Negro pencil.

Try to experiment with all of the techniques shown, including those preceding the step-by-step demonstrations.

PONT NEUF, *10¼″ x 11½″ (26 x 29.2 cm)*. This drawing of my favorite bridge in Paris is basically a tonal rendition. Here I have used the Koh-i-noor Hardtmuth Negro pencil on a smooth, high-finish Strathmore four-ply bristol board. I began by first drawing in the darkest areas and then adding the intermediate and lighter tones.

Semi-realistic Rendered Tone

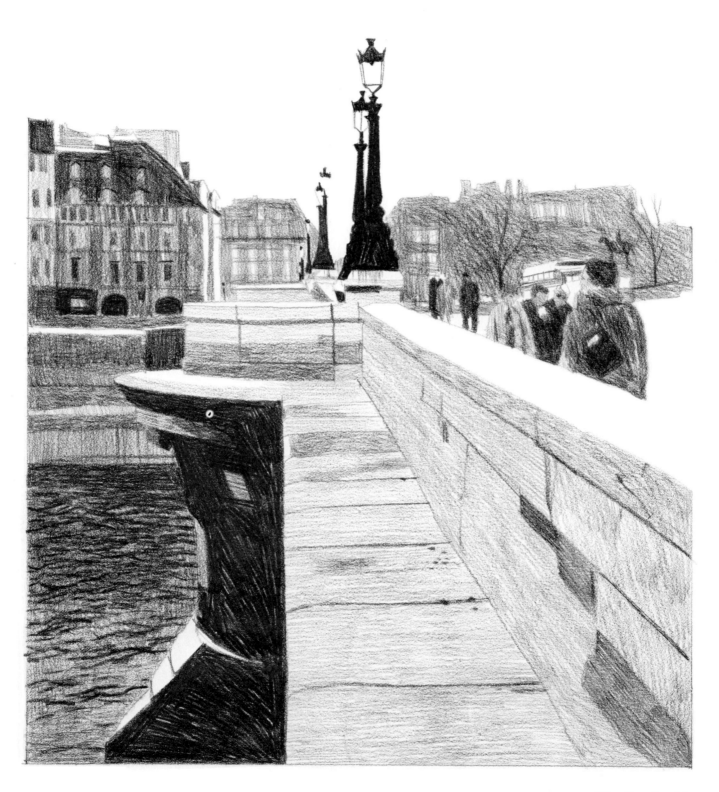

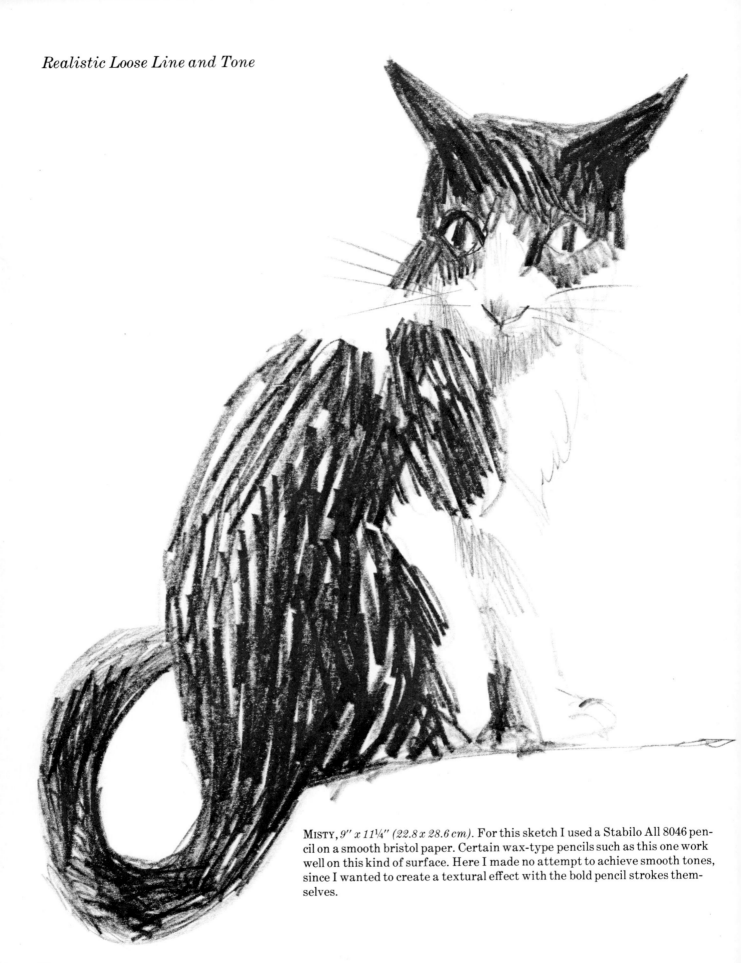

MISTY, *9″ x 11¼″ (22.8 x 28.6 cm).* For this sketch I used a Stabilo All 8046 pencil on a smooth bristol paper. Certain wax-type pencils such as this one work well on this kind of surface. Here I made no attempt to achieve smooth tones, since I wanted to create a textural effect with the bold pencil strokes themselves.

PONT NEUF, *10″ x 10″ (25.4 x 25.4 cm)*. This drawing illustrates a linear technique on a textured paper surface. It consists of a rather heavy line with only a few simple, flat tones for accents. It was done with the Stabilo All pencil.

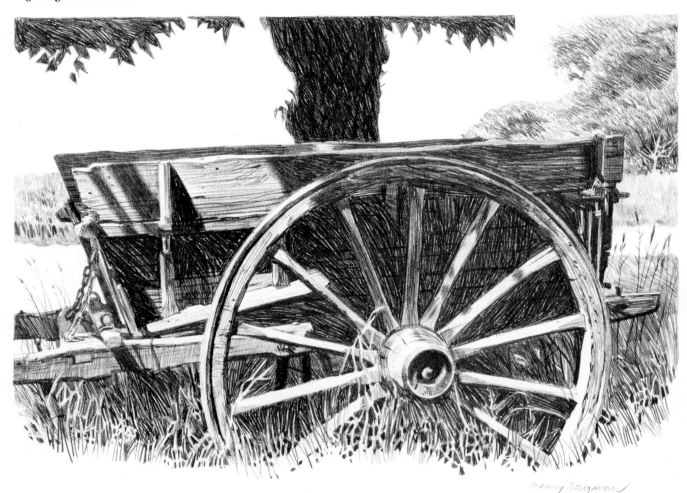

Above. FARM WAGON, *14½″ x 10½″ (36.8 x 26.7 cm)*. A very realistic, highly detailed example of what can be done with the Koh-i-noor Hardtmuth Negro pencil, this drawing is done on a smooth bristol surface.

Right. REFLECTIONS, *10⅛″ x 13⅝″ (25.7 x 36.6 cm)*. The Koh-i-noor Hardtmuth Negro pencil is great to work with because with it you can achieve a wide range of gray tones as well as jet black. The highly detailed and meticulously rendered technique shown here is rather difficult and time consuming especially for the beginner. Therefore, it is very important to have good reference material when attempting a drawing like this. Since it is difficult, if not impossible, to do such a drawing on the spot, it is best to work from photographs.

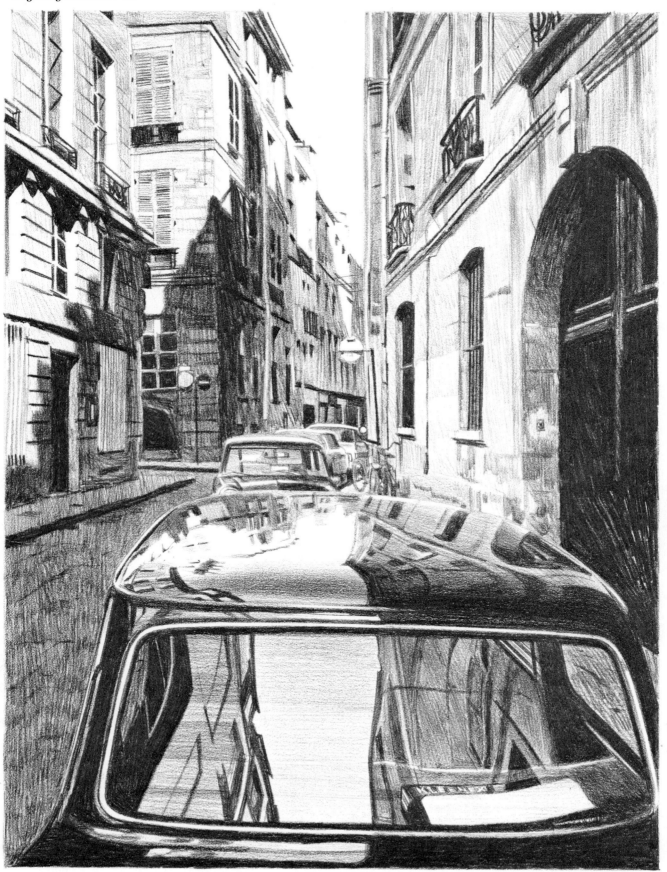

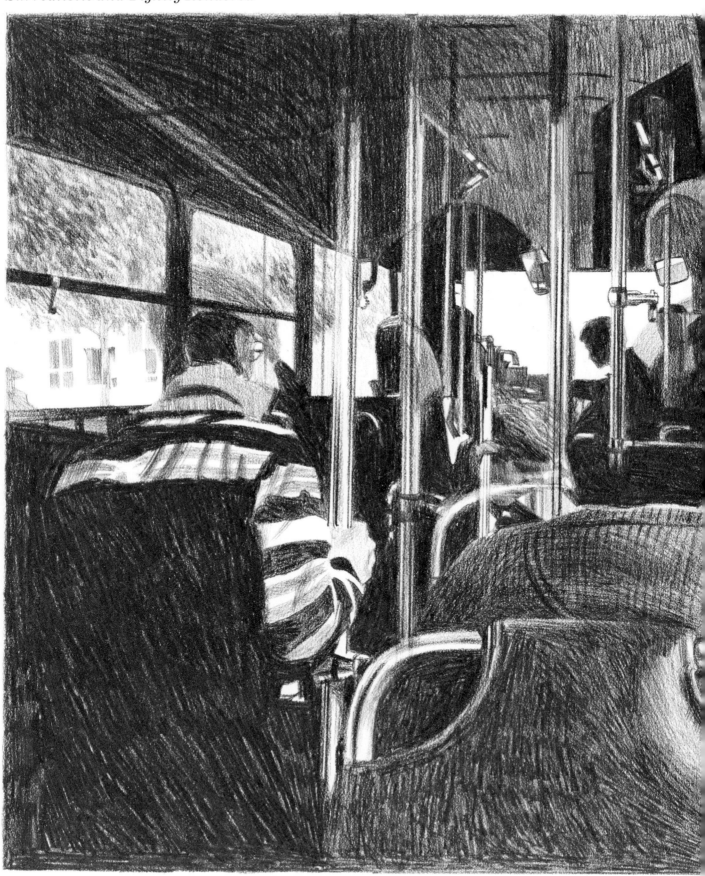

CITY BUS, *12½″ x 10¼″ (31.8 x 26 cm)*. This drawing is another done with the Negro pencil on a smooth paper surface. The subject matter is taken from a deliberately double-exposed photograph which I took as part of an experiment. When drawing from photographs, you don't necessarily have to just copy the image, you can add things, leave out sections, combine photographs, or just change the scene as you see fit.

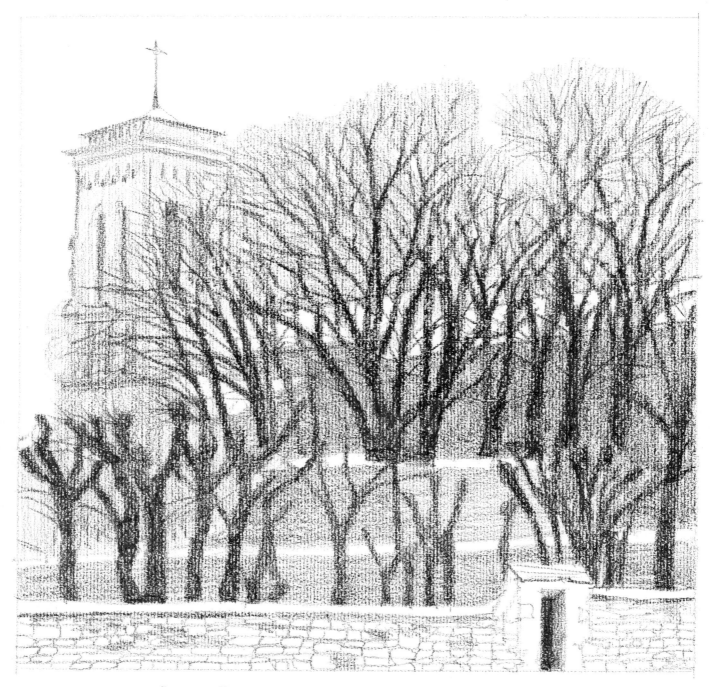

CHURCH AT VEZELAY, *11″ x 11″ (28 x 28 cm)*. Drawn on Ingres Canson paper with a Stabilo All pencil, this rendition is primarily made up of just tones.

Decorative Line-Tone on Colored Paper

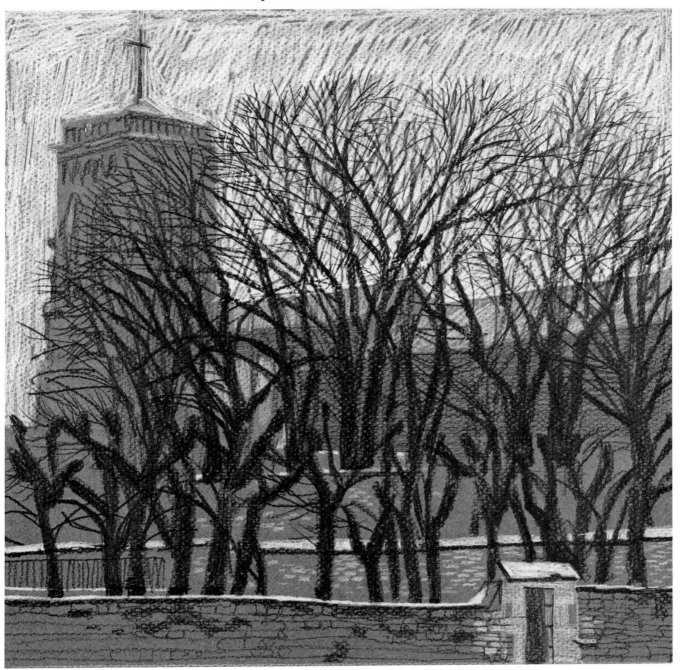

CHURCH AT VEZELAY, *11″ x 11″ (28 x 28 cm).* This is the same scene as the previous example but this time done in a different technique. Here I used an Eagle Verithin 734 white pencil and a Koh-i-noor Hardtmuth Negro pencil on a colored paper.

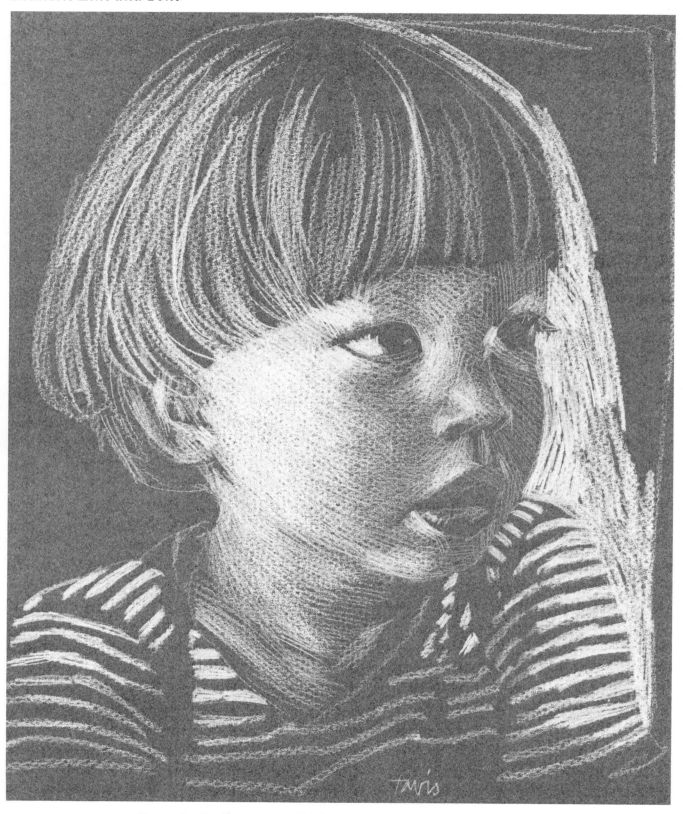

TAVIS, *8″ x 9⅝″ (23 x 24.5 cm)*. This is exactly the same portrait as the one on pages 50 and 51. Compare this one with the other drawings. By using only Eagle Verithin white pencil on a colored paper, the whole feeling of the portrait has been changed.

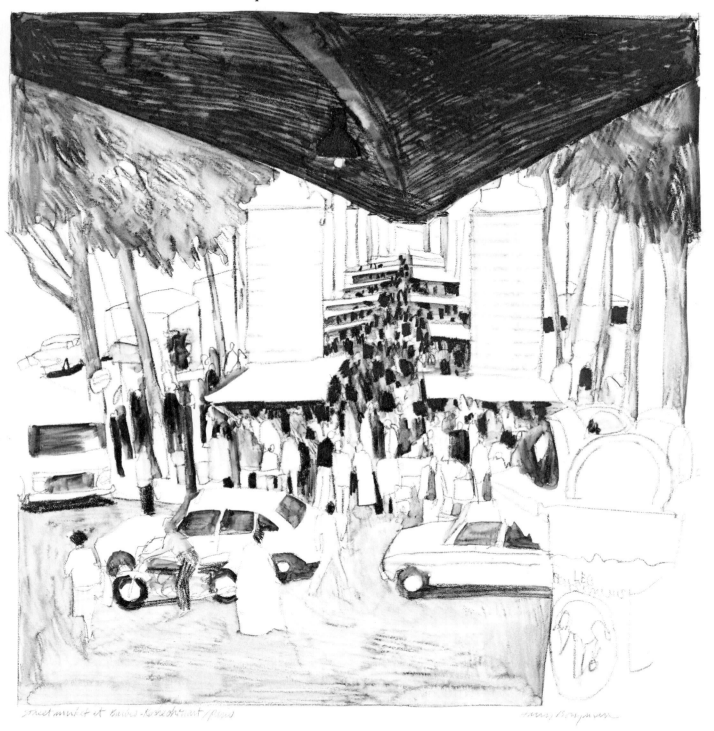

STREET MARKET, BARBES-ROCHECHOUART, PARIS, *13½″ x 13⅞″ (34.1 x 35.3 cm).*
The Stabilo All pencil is interesting. The lines and tones drawn with it can be
easily dissolved by washing water over them with a brush. This adds a whole
new dimension to pencil drawing. Here I first did a line drawing and then
added a few light gray tones over which I used a brush with clear water, dis-
solving the tones into washes. This drawing was done on a very smooth bris-
tol surface—a paper not usually used for wash drawings, since a textured pa-
per is usually preferred for washes.

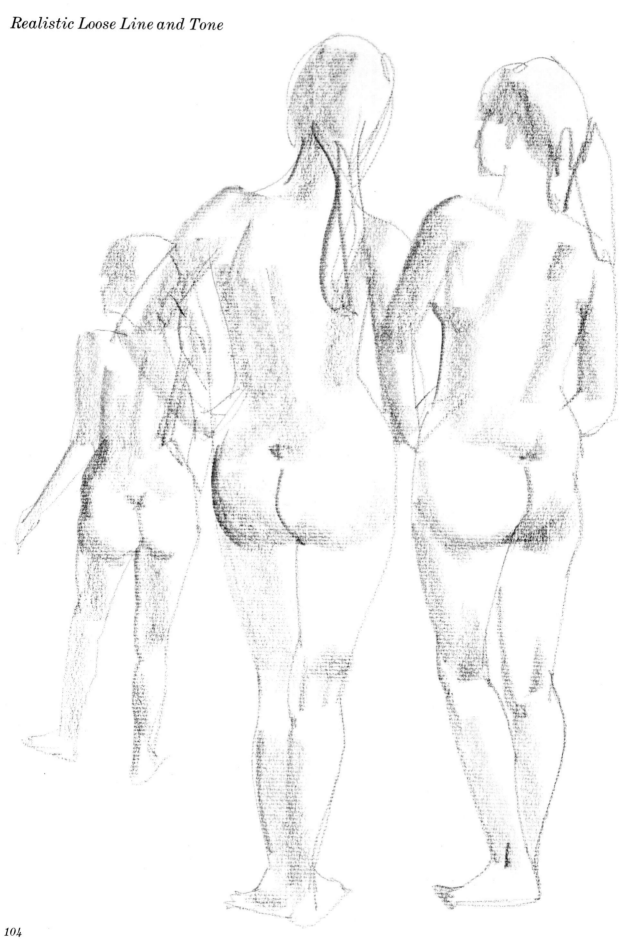

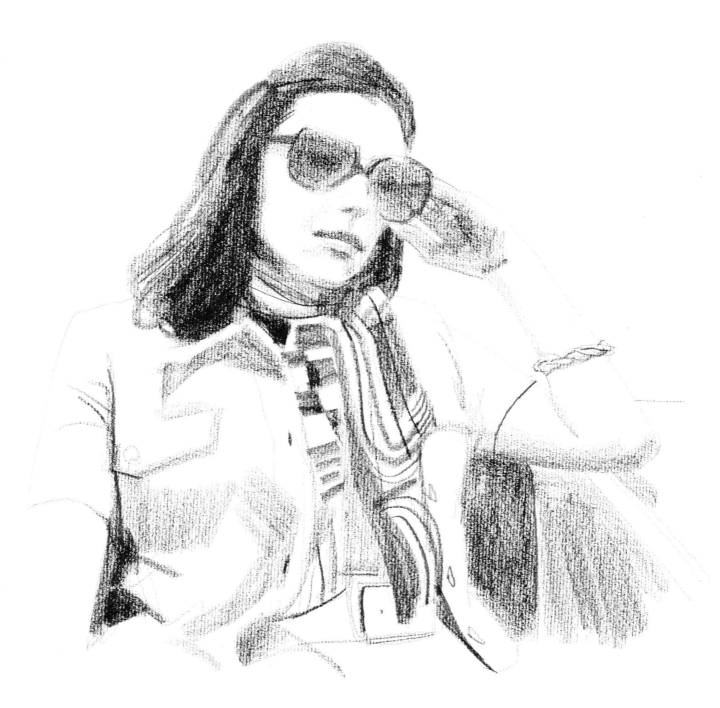

Above. JEANNE, *11¼″ x 10⅝″ (28.1 x 27 cm)*. Conté crayon is an interesting medium to use for quick sketches since unusual effects can be achieved by drawing with different edges of the square-shaped crayon. This sketch was done on Ingres Canson paper with a number 1 black Conté crayon.

Left. NUDE STUDIES, *9½″ x 14½″ (24.1 x 36.8 cm)*. Years ago, when I was a student in life-drawing classes, I really enjoyed drawing with the Conté crayon. This is a marvelous medium to explore and is especially well suited for doing quick sketches.

Demonstration 8. Decorative Water-Dissolved Tone

The Stabilo All pencil, which works very well on smooth-surface papers, can also be used on very rough-textured papers such as those made for watercolor. This technique is especially good for sketching on the spot.

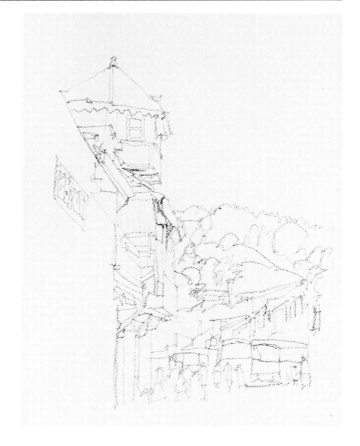

Step 1. On Arches paper mounted on a watercolor block of twenty-five sheets, I begin with my basic line drawing using the Stabilo All number 8046 pencil.

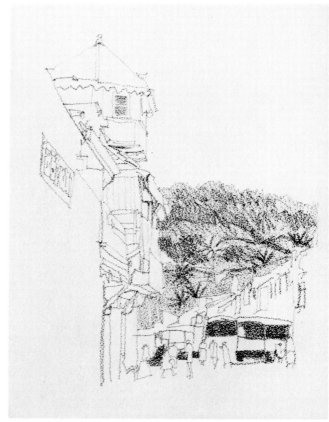

Step 2. I add some tones in the background foliage and put a few darks in the vehicles as well as in the shadow areas.

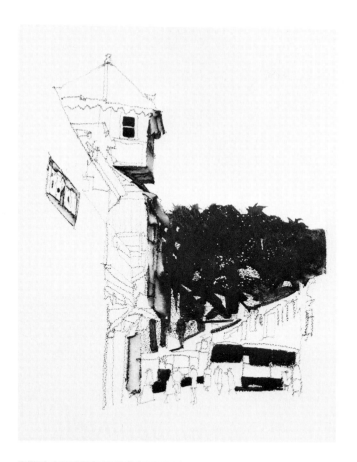

Step 3. With a watercolor brush—a red sable—I wash clear water over the mountain areas, dissolving the pencil tones into a dark wash.

Step 4. To create gray tones, I add more clear water to the front of the building, the buses, and the figures.

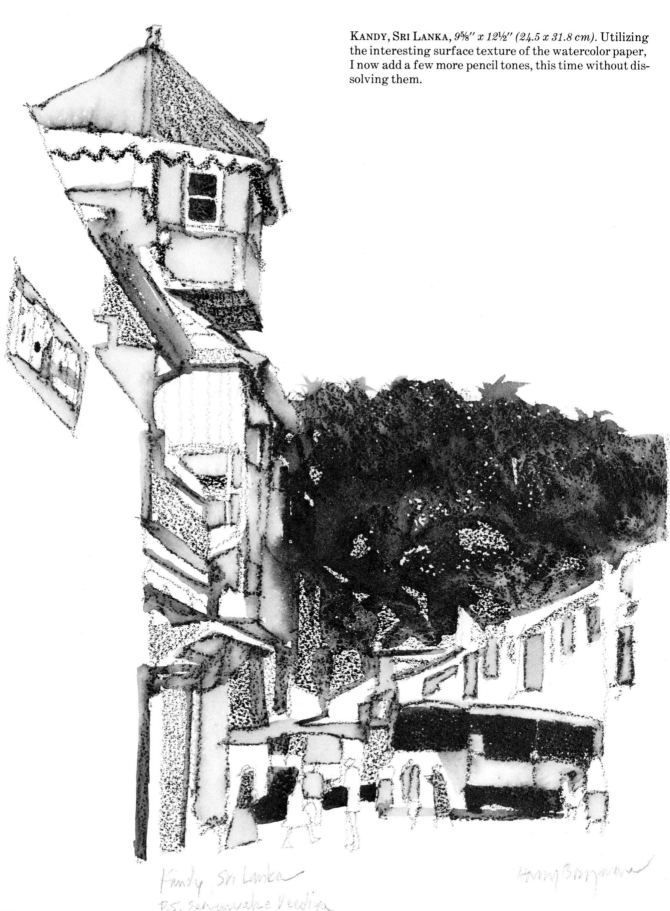

KANDY, SRI LANKA, *9⅝″ x 12½″ (24.5 x 31.8 cm).* Utilizing the interesting surface texture of the watercolor paper, I now add a few more pencil tones, this time without dissolving them.

Demonstration 9. Tightly Rendered

The Koh-i-noor Hardtmuth Negro pencil is excellent to work with, and the range of tones that can be achieved with this drawing tool are amazing. This demonstration illustrates a technique for which the Negro pencil is particularly well suited. However, it is a difficult, time-consuming technique, and may not suit someone just beginning to draw. This demonstration was done from photographs taken while on vacation in Bali.

Step 1. I begin by first doing my basic drawing on Strathmore high-surface bristol board.

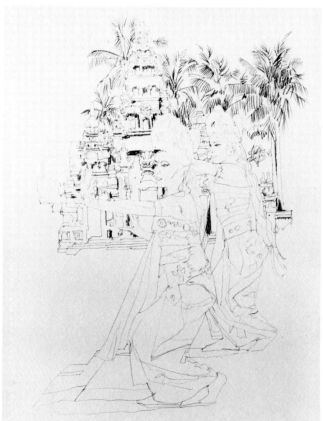

Step 2. At this point, I decide to make the drawing more interesting by adding trees and a Balinese temple to the background.

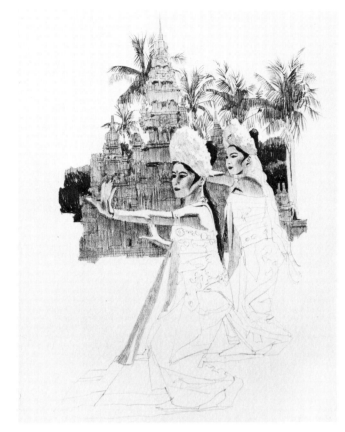

Step 3. I now add skin tones to the arms and faces of the dancers and draw in the dark hair. I then place dark accents in the trees.

Step 4. I continue working on the dresses of the dancers and gradually build up the skin tones. I now darken the temples in the background and add details to the costume of the dancer on the right. To create a better composition, I add shadows on the ground and put more trees on the right side of the background.

Opposite page. Legong Dancers, *11″ x 17⅝″ (28 x 44.8 cm).* I now finish the dress of the dancer in the foreground and darken the skin tones of the arm slightly. At this point I also clarify many of the facial details. I then decide that the foreground is far too bright and add a light tone over this area, subduing it. While I draw, I am very careful not to get any tones too dark, so I build up the values very slowly. With this technique, it is always possible to darken tones, but it is quite difficult to lighten them. If you work very carefully, however, you can lighten some tones by scraping them with an X-acto knife.

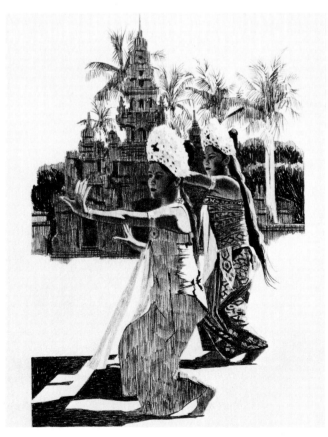

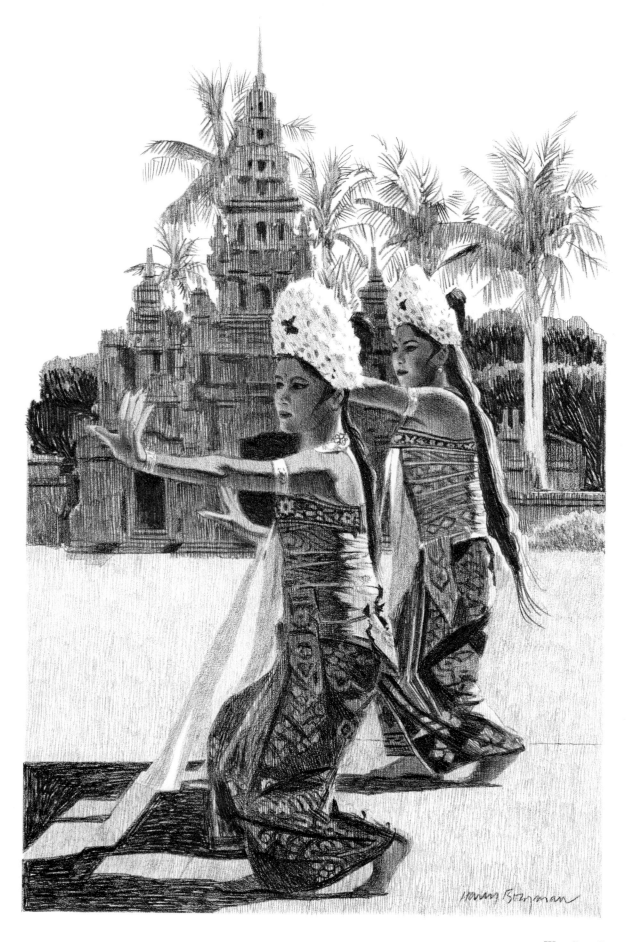

Chapter Six
Color Pencils

Many artists ignore or simply don't take color pencils seriously as a medium. The purists argue that true pencil drawing is done in only black and white. Although this may be true to a certain extent, since some of the finest pencil drawings are in black and white, color does offer a unique challenge.

Color pencils are ideal as a dry-sketch medium for on-the-spot drawings or color studies. Later such drawings or studies can be developed into more finished drawings or into paintings. Some very finished drawings can even be done with color pencils. And they will stand up well against other mediums.

Each person must decide individually the merits of color pencils as a medium. I personally feel they are an excellent medium, and I have seen an increasing amount of color-pencil work being done in both the fine art and commercial art fields. So it appears that other artists feel as I do.

Obviously color is complicated for the beginner, so don't attempt color work until you've mastered at least a few of the black-and-white techniques. In the examples that follow, you will find techniques that include line and tone, stump-blended tone, and tone on colored paper. The subjects are varied and include a still life, animals, outdoor scenes, figures, and portraits. This section includes three step-by-step demonstrations, which show line and tone, blended tone, and a tightly rendered tone-drawing technique.

JEANNE, *10⅜″ x 12″ (26.4 x 30.5 cm)*. Using MBM Ingres d'Arches paper, I did this drawing using pastel pencils in a very soft technique. The Carb-Othello pencils are available in an extensive color range and handle particularly well on a textured paper. The soft, hazy effect in this drawing is difficult to achieve with other types of pencils.

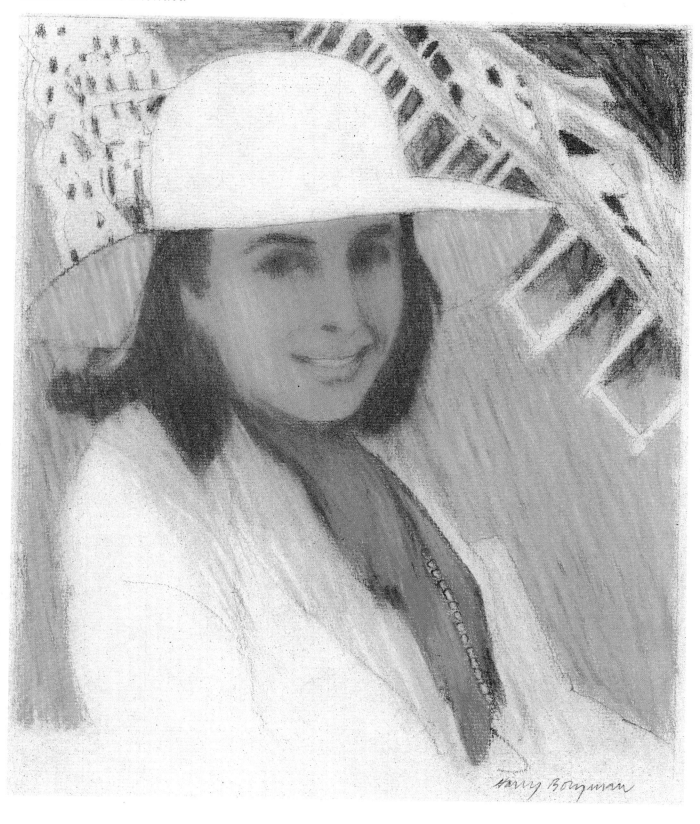

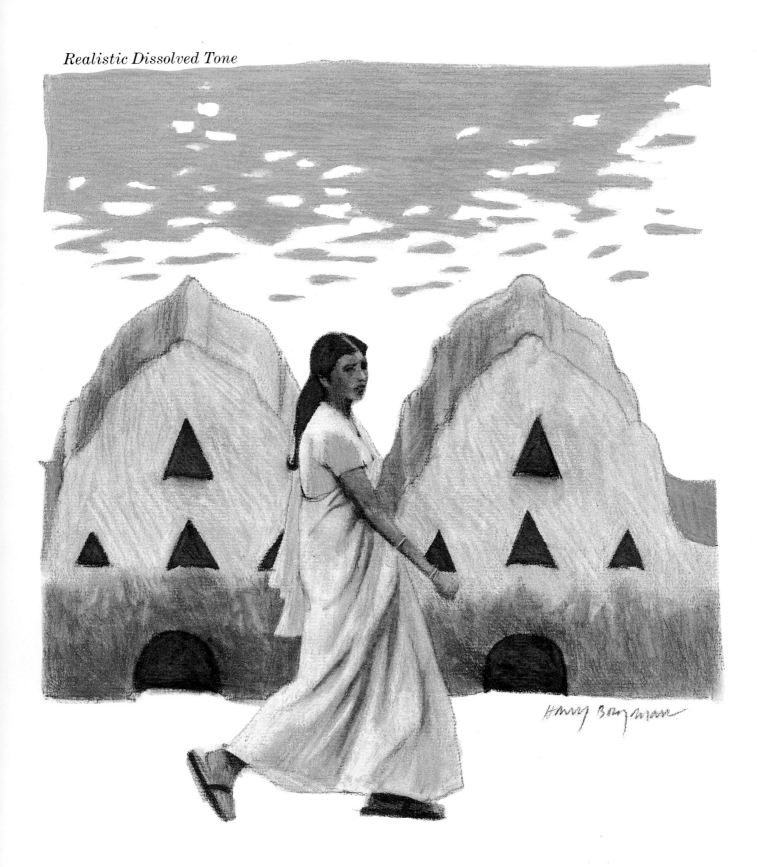

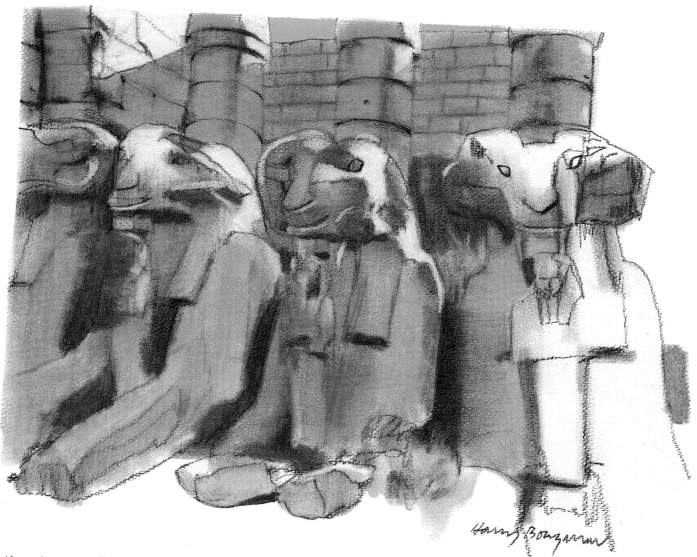

Above. AVENUE OF SPHINXES, KARNAK, *10½″ x 8″ (26.5 x 20.3 cm).* This drawing was done on Canson Lavis B paper with Berol Eagle Prismacolor pencils. This paper has a nice, evenly textured surface that works very well with these pencils. The basic line drawing was done with a cold gray 965 pencil over which the color pencils were used. The pencils used for this drawing were green bice 913, cream 914, orange 918, nonphotographic blue 919, blush 928, yellow ochre 942, terracotta 944, dark grays 965 and 966 and a light cold gray 967. After completing the rendering, I blended the colors with a rolled paper stump dampened in Bestine, which dissolves this type of pencil easily.

Left. ALONG KANDY LAKE, *10½″ x 12″ (26.7 x 30.5 cm).* In this example I used Prismacolor pencils on MBM Ingres d'Arches paper. Notice the effective use of the white paper in this picture. Keep in mind that you don't have to cover every square inch on your paper with tones or color when doing a drawing. Fifty percent of this drawing is composed of the white paper itself. I began this study by first doing a basic line drawing, building up my color tones over this. The colors were then blended with a paper stump dampened with Bestine. Some of the effects achieved with this technique are very similar to those attained with paint.

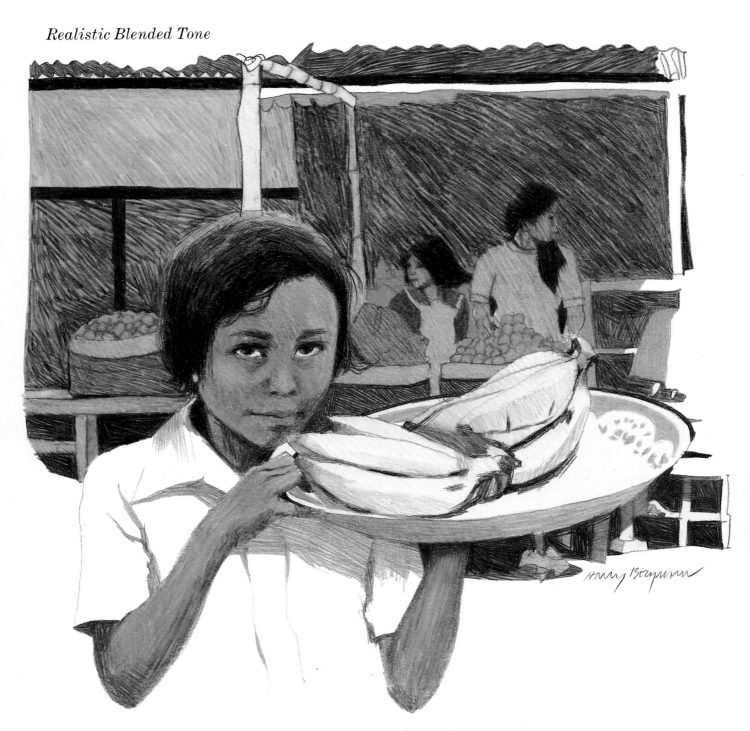

Above. BANANA GIRL, BESAKIH MARKET, BALI, *11½″ x 11⅜″ (29.2 x 28.9 cm).* For this drawing I used the Prismacolor pencils on a smooth-surface bristol board. This basic drawing was done with a dark cold gray 965. I gradually built up my color values and tones, being careful not to get any area too dark. If you do happen to overwork an area and the tones become too dark, it is fairly easy to erase these pencils and start over. This rendering is quite realistic, but I deliberately kept the background flat and simple for a strong design effect.

Right. BESAKIH, BALI, *10⅞″ x 13⅜″ (27.5 x 34 cm).* Certain pencil brands, such as Prismalo and Stabilo are water soluble, a unique quality that can be utilized to create some very interesting effects. You can actually do paintings with these pencils, really extending the possibilities of the pencil medium. This pencil painting was done on a four-ply medium-surface bristol board. I completely rendered the scene with the pencils, then washed on clear water with a brush, dissolving certain tones into washes. Some of the interesting leaf textures were accomplished by first putting drops of water on the area and then blotting up the dissolved color with a paper towel.

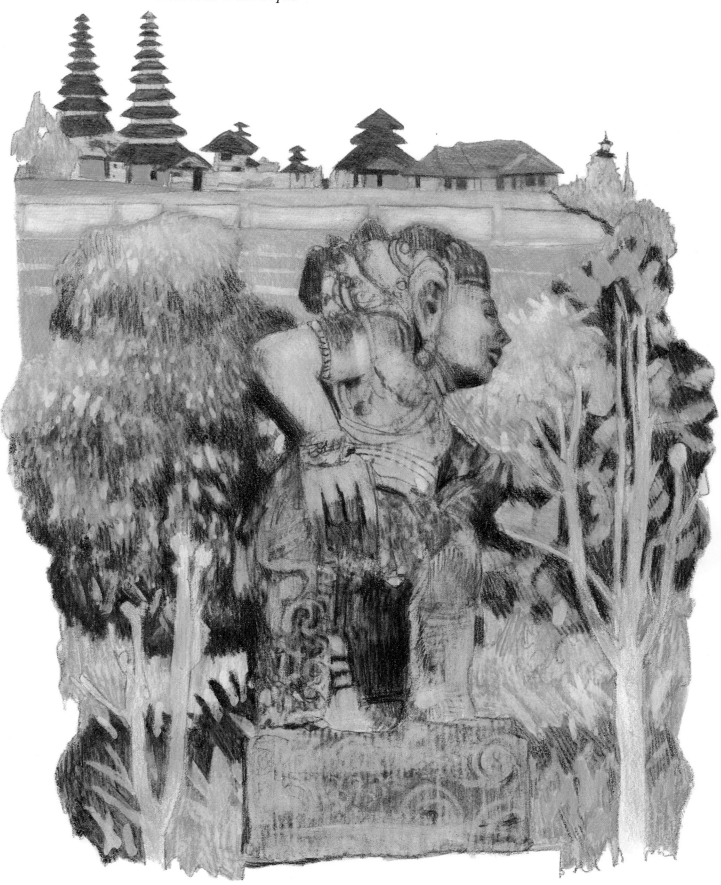

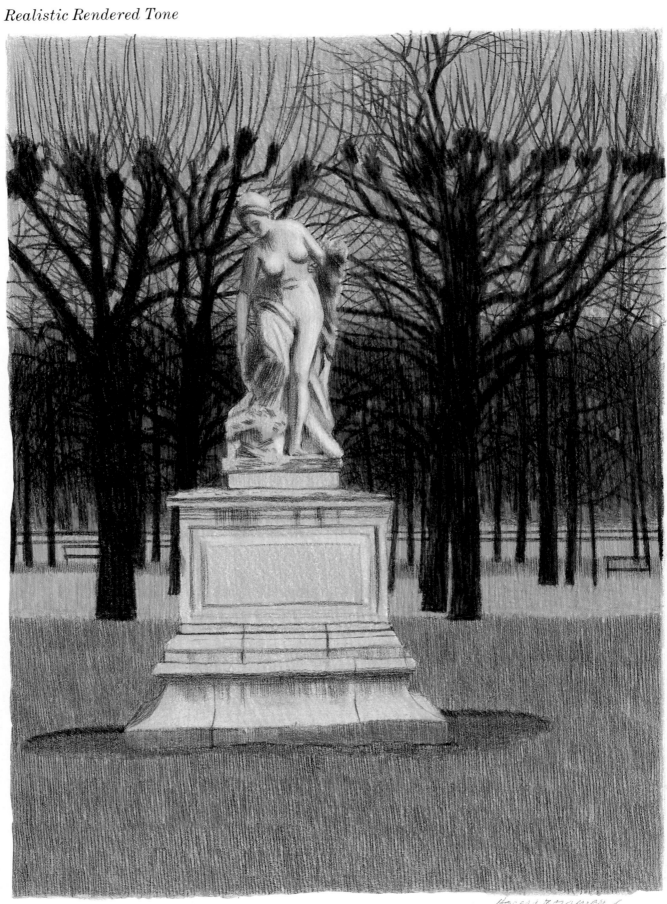

Line-tone on Colored Paper

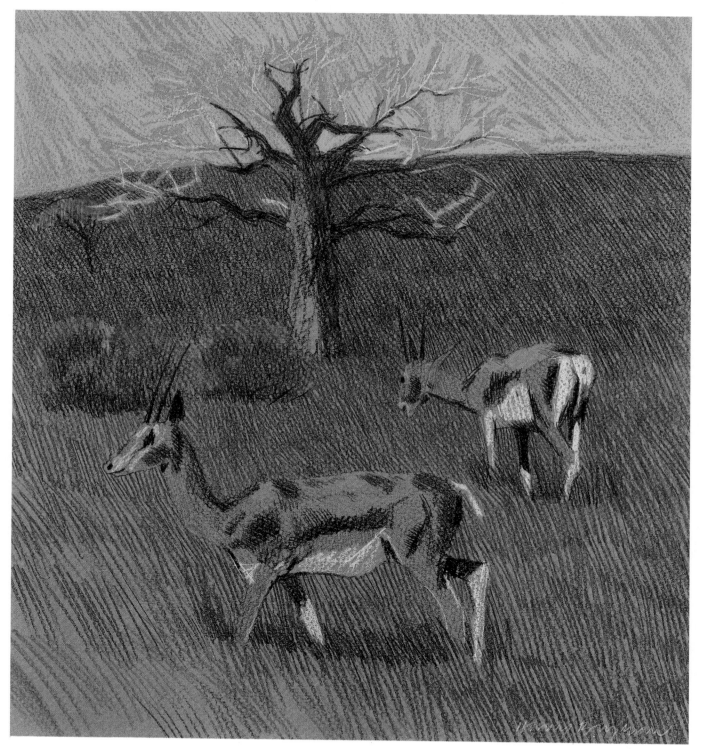

Left. TUILLERIES, *10″ x 13¾″ (25.4 x 35 cm).* My basic drawing was done with a Stabilo black 8746 pencil on a medium-surface bristol board, which has a slight texture that is nice for pencil work. So that the rendering would remain fresh, I slowly built up my color tones, being careful not to overwork any one area.

Above. IN TSAVO PARK, *11″ x 12⅜″ (28 x 31 cm).* This drawing was done with only six different color pencils on a colored paper. I used the Stabilo black 8746, white 8752, green 8723, Prismalo brown 50, yellow 10, and blue 171. I made no attempt to blend any of the colors. I just made the pencil strokes rather bold to convey the feeling of grass texture.

Demonstration 10. Color Pencils on Textured Paper

This demonstration is drawn on MBM Ingres d'Arches paper with Prismacolor pencils. It is done in a pretty straightforward technique with no blending of tones. The texture of the paper adds a great deal of interest to the drawing.

Step 1. Not being quite sure how the color should be handled on this drawing, I decide to do a color sketch. I lay a sheet of transparent layout paper over my basic pencil drawing and roughly trace the general shapes with a Pentel Sign pen. Then, using Magic Markers, I fill in the rough sketch until I achieve the effect I'm after. My first sketch worked out well, so I can proceed to the finished pencil drawing. It is a good idea, especially if you are a beginner, to do two or three rough color sketches before starting your finished color drawings.

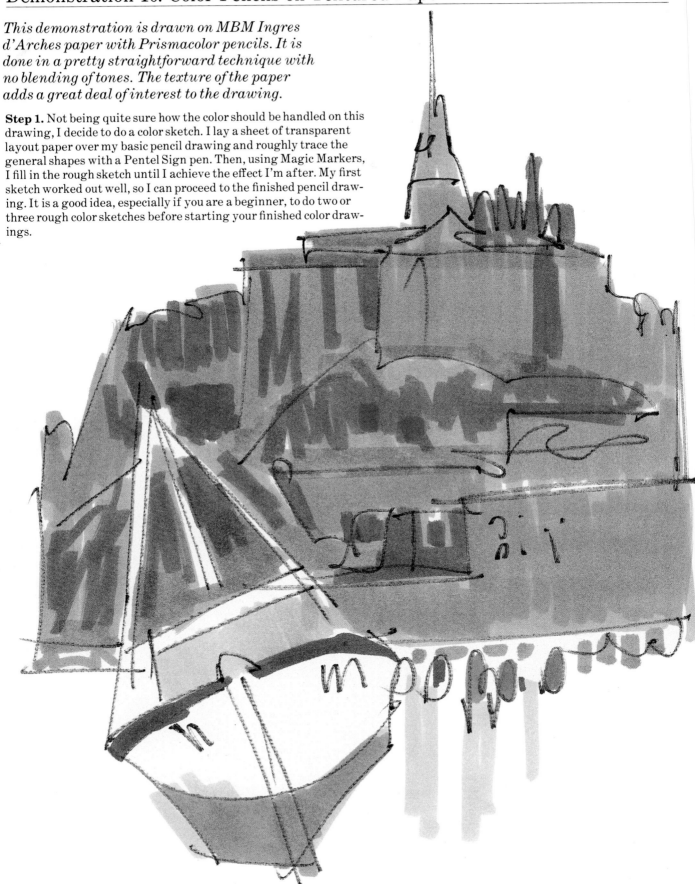

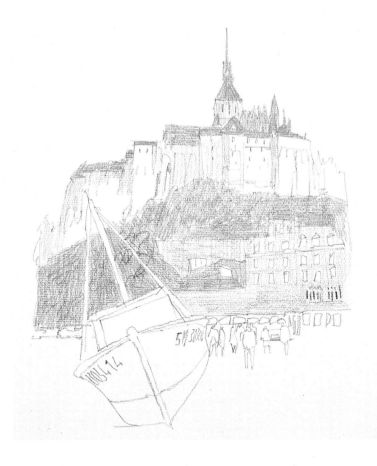

Step 2. I now begin putting color in the pencil drawing, using the Magic Marker sketch as a guide. I draw in the foliage using an apple green 912 pencil. I use an orange 918 as an undertone on the buildings and sketch it lightly over the foliage as well, warming the color up a bit. I then fill in the roofs with a light cold gray 967.

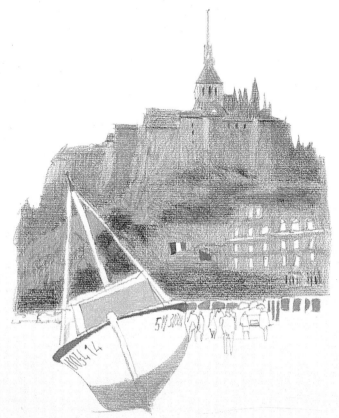

Step 3. Using a raw umber 941 pencil, I draw a tone over everything—the foliage, the buildings, and the hills. With a sand 940 I lighten up the foliage and then add some soft shadows over the background with a sepia 948. I then use a light, cool gray 964 tone on the foreground boat, and place in the red accents with a scarlet red 926. To complete this stage, I add a tone of flesh 999 over the buildings and then put a tone of sand 940 over that.

MONT ST. MICHEL, *15″ x 9⅞″ (25.1 x 33 cm)*. With the black 935 I carefully add windows and other building details as well as a texture to the foliage. I put a few bright spots of color on the people, add the reflections, and finish the drawing. This is a good technique for almost any subject.

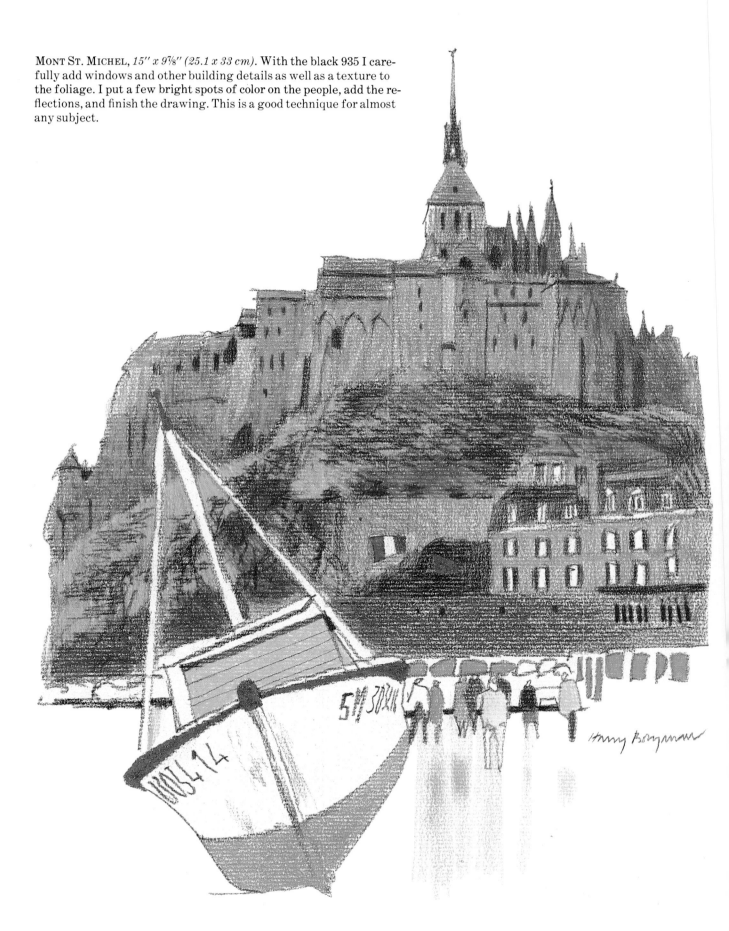

Demonstration 11. Color Pencils on Pantone Paper

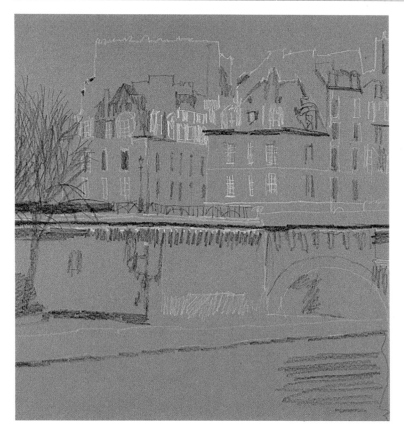

Drawings done on a colored paper can be very effective, but the subdued colors work better than the brighter colors.

Step 1. I begin by doing a rough drawing with both black and white Prismacolor pencils on a sheet of Pantone paper number 446.

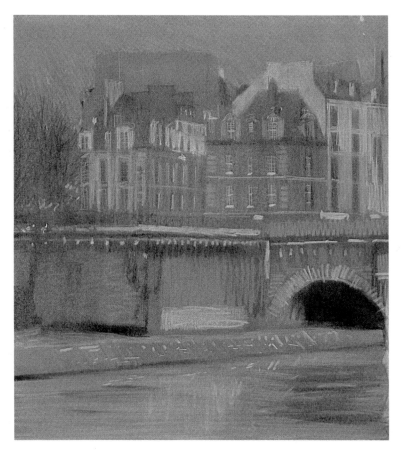

Step 2. I work on the buildings with sand 940, light warm gray 964, and blush 928, and I use a nonphotographic blue 919 and light gray in the sky as well as in the water. I also add black shadows under the bridge and in some of the other details on the buildings. I then dampen a rag with Bestine and blend all the colors; this softens everything nicely. I also keep working with the light gray, blue, white, and umber pencils, adding shape and form to the buildings, and drawing reflections in the water.

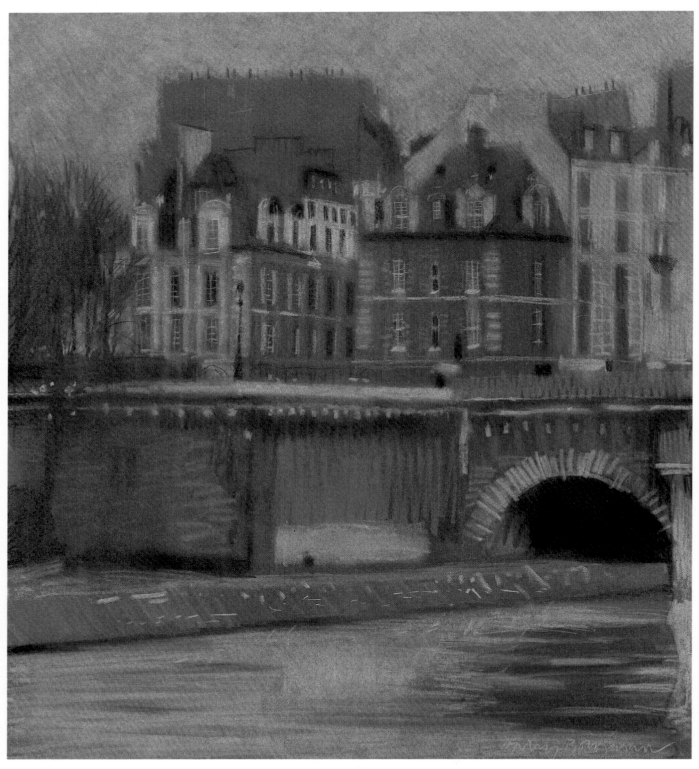

Pont Neuf, La Cité, *10⅝″ x 12″ (27 x 30.5 cm)*. With a flesh 927, I highlight and bring out some of the building details. I use the same pencil in the sky to lighten the color value. With a paper stump dampened with Bestine, I soften and slightly blend everything. I add some final details with a black pencil and soften these with the paper stump.

Demonstration 12. Color Pencils on Regular-Surface Bristol

The slightly textured bristol surface can also be used to achieve very realistic effects with certain techniques. The technique demonstrated here is quite similar to some of the other highly rendered examples shown earlier in the book. But this is not a drawing project for the beginner. It is probably more appropriate for the advanced student. If you are a beginner, don't attempt drawings like this until you have had a lot of experience with some of the simpler techniques.

Step 1. On a sheet of regular-surface bristol, I do a basic drawing using a medium warm gray 962 pencil. I begin adding color by filling in the sky background with a light flesh 927. Over this color I use a light cold gray 968.

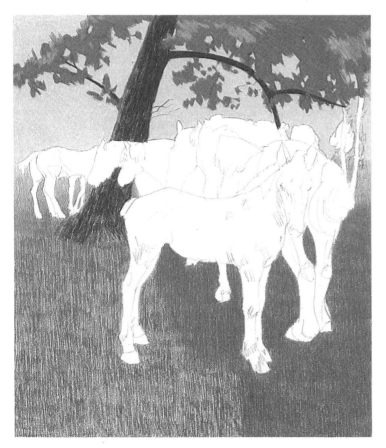

Step 2. I draw in the dark tree with a medium warm gray 962 and put green bice 913 over the background grass area, with orange 918 added over it. I then paint raw umber 941 over the whole foreground area. On the leaves I add green bice, light green 920 for the highlight accents, and some slate gray 936 for the shadow areas in the leaves. I also begin to use the slate gray to darken the foreground shadow area.

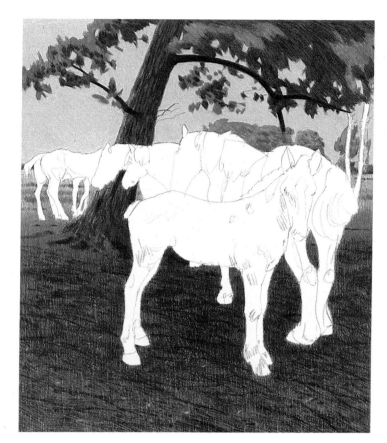

Step 3. I continue to darken the foreground shadow area, and with a dark cold gray 965, I also darken the leaves. I then go over the whole foreground area very carefully, darkening it with the dark gray. This takes a great deal of time and cannot be rushed if an even tone is to be achieved. I now add ground textures and other details to the shadow area.

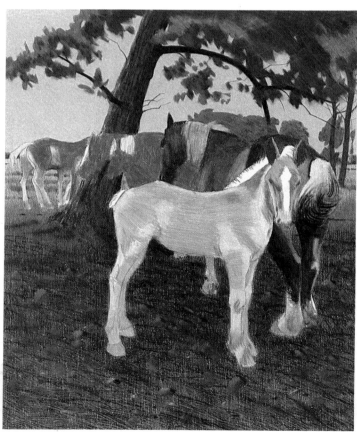

Step 4. I color in the colt with a light flesh 927 and a raw umber 941. I then use a sienna brown 945, a dark cold gray 965, and a light cold gray on the other horses. I slightly soften all these tones with a paper stump dampened in Bestine and use the paper stump on the trees and foliage. I even pick out details and rock shapes in the foreground with the paper stump.

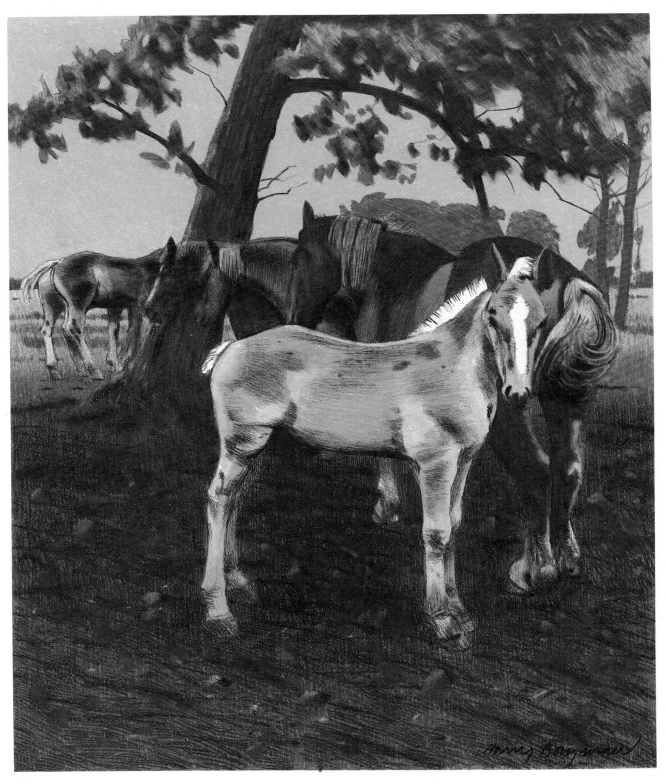

THE COLT, *11⅛″ x 13½″ (28.2 x 34.3 cm)*. With a black pencil I add details to the horses and finish them. Then I slightly blend the tones on the horses with the paper stump. With the paper stump dampened in Bestine, I then pick out a few highlights in the leaves and go over these areas with a green bice pencil to brighten them.

Mixed Media

You might well ask, "Why mix media when pencil drawings can well stand on their own?" For one thing, combining pencils with other media offers unlimited opportunities for experimentation. Mixing can also introduce you to watercolors, colored inks, dyes, gouache, and even acrylic paints.

Often a rather ordinary pencil drawing can be greatly enhanced simply by adding a watercolor or ink wash. In fact, adding a simple wash to pencil drawing is probably the best way to begin working with mixed media. You don't even have to use color; a wash of water-soluble ink will work nicely.

Remember, color is much more difficult to work with. After you've gained a lot of experience working in black and white, you can try color.

Becoming familiar with mixed media will certainly help you with more complicated mediums, such as watercolor and other paints. When you do begin working in color,

start out with watercolors or dyes, and use very simple washes. It would probably be helpful to do a rough color sketch in Magic Markers before beginning a mixed-media drawing. Such color sketches can be invaluable as guides for a final color rendering.

On the following pages I show several interesting combinations of mediums. In the black-and-white examples, you will see graphite pencils with water-soluble ink, gouache washes, oil crayons, and acrylic paints. The color section includes examples of color pencils combined with markers, designers' colors, watercolors, and oil crayons. In a few cases I have blended the mediums with a solvent, achieving effects impossible with another method. The step-by-step demonstrations show color pencils combined with dyes, gouaches, oil crayons, and acrylic paints. Although some of these techniques are not major ones, they certainly merit consideration and are well worth exploring.

KONGONI, *11" x 15¾" (28 x 40 cm)..*Prismacolor pencils and oil crayons were used for this drawing done on MBM Ingres d'Arches paper. Very bold strokes throughout created an overall texture. This is an ideal technique for sketching on the spot, but this particular example was drawn from photographs taken in Kenya.

Semi-realistic Tone Blending

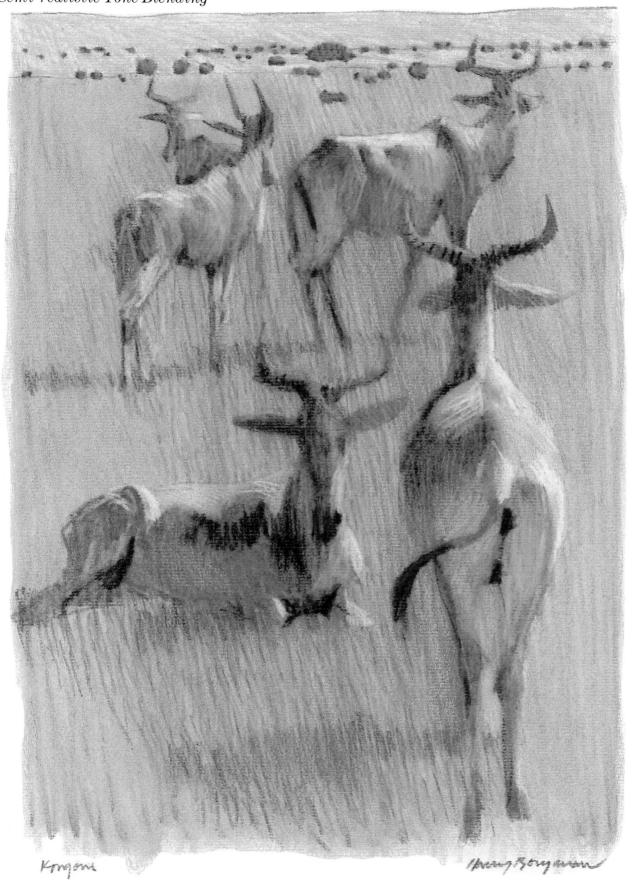

Kongoni

Harry Borgman

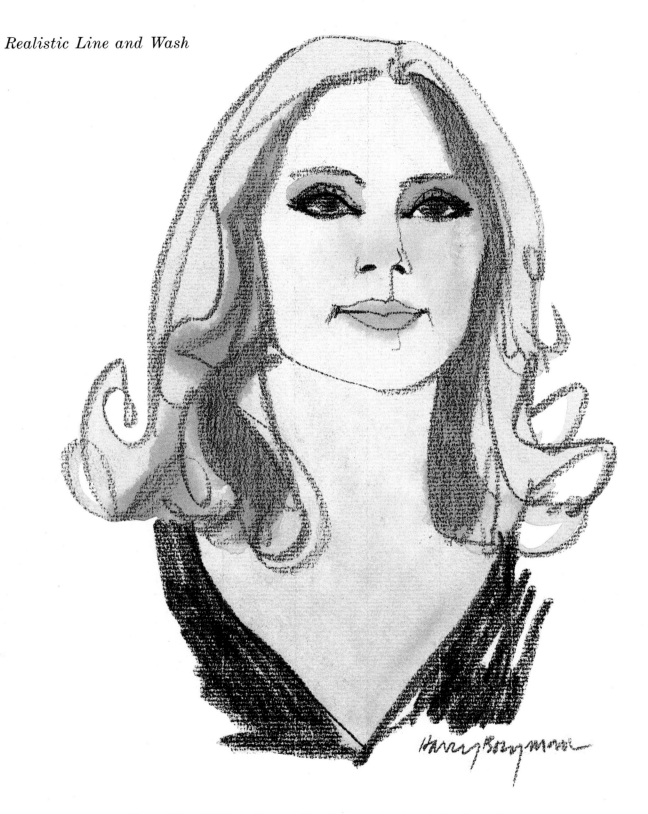

MONA, *7⅜″ x 10″ (18.8 x 25.4 cm)*. Here is a very simple yet effective technique for drawing portraits, and it can be used for many other subjects as well. This is the technique I often use when sketching while traveling. You simply do a line drawing or line sketch and fill it in with watercolor washes. You can also use dyes, gouache, or even acrylic washes as well. This drawing was done on MBM Ingres d'Arches paper, but most other paper surfaces, with the exception of the smooth-surface bristol, would work quite well.

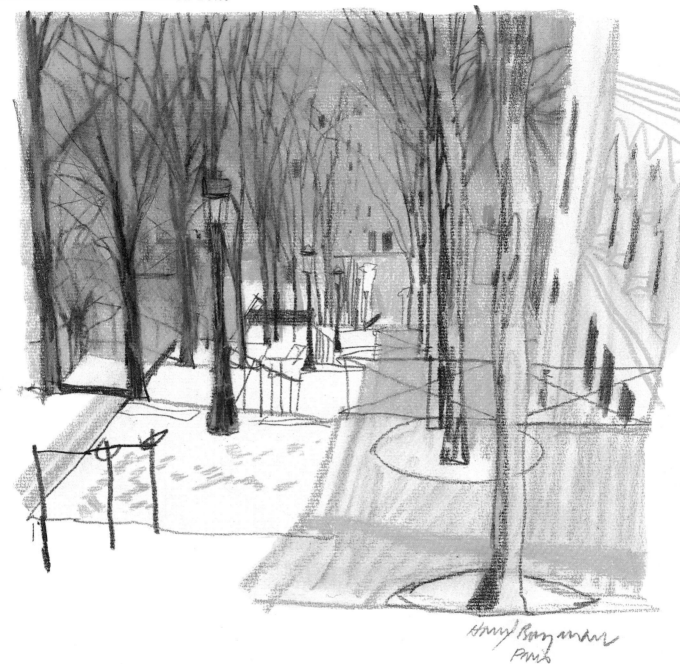

MONTMARTRE, *11¼″ x 10¾″ (29.2 x 27.3 cm).* Color pencils, oil crayons, water, and turpentine were used in this example. After the tones were rendered, water was washed over certain areas, dissolving the water-soluble pencil tones. Then I added some oil crayon tones and blended these with a rag dampened with turpentine. The sketch was completed by redrawing certain things, such as the trees, that had been dissolved. By the way, the tree trunks really were green because they were covered with moss.

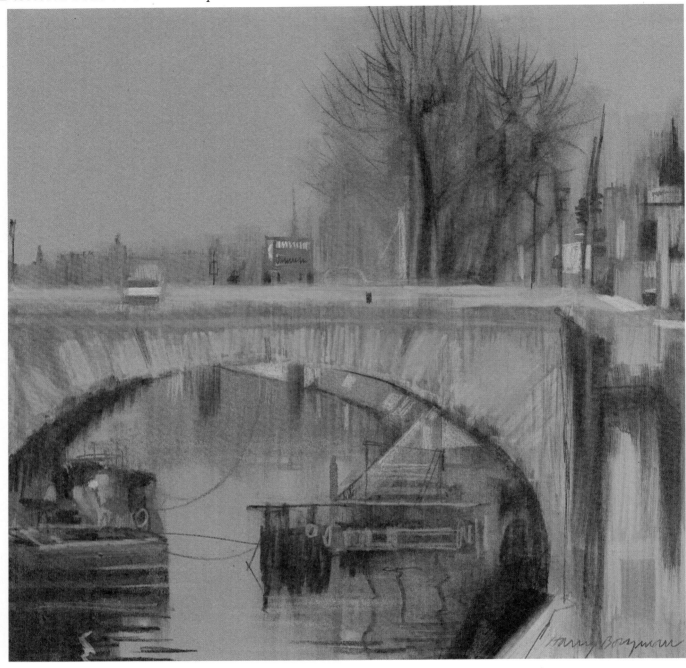

Above. PARIS MOOD, *10¼ x 10¼″ (26 x 26 cm).* Here I used Primacolor pencils on a sheet of Pantone paper, number 535. This was a typical gray day in Paris, and the bright-colored signs accented the scene perfectly. This is primarily a tone study with little use of line. The color pencils used here were: dark cold gray 965, light cold gray 964, medium cold gray 966, and white 938. When the rendering was completed, I blended these colors with a Bestine-dampened paper stump. Then I used a canary yellow 916, light blue 904, and carmine red 926 for the color accents. This is a very simple, but surprisingly effective, technique using a minimum of colors.

Right. PARIS BIRD MARKET, *8½″ x 12⅛″ (21.6 x 30.8 cm).* Color pencils, Magic Markers, oil crayons, pastel pencils, and Bestine were all used on Pantone paper, 443, for this study. Don't be afraid to try any combination of media with pencils—ink or even dyes will work very well with them. It's fun to experiment, and you'll often achieve interesting results that would otherwise be impossible. If you explore, you'll never get bored with this kind of pencil drawing.

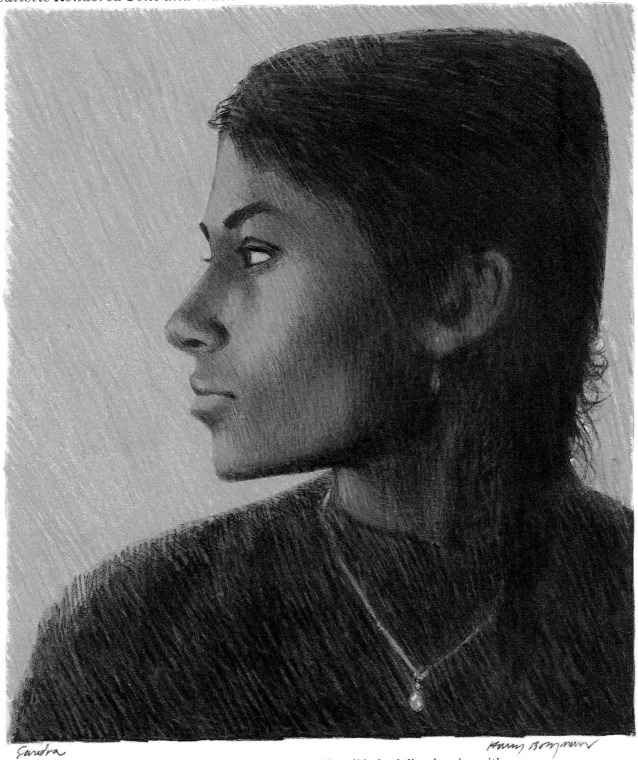

Sandra Harry Borgman

SANDRA, 9¾″ x 11¾″ (24.7 x 29.8 cm). I first did a basic line drawing with a
Negro pencil on a medium-surface bristol board, over which I painted a flesh-
tone watercolor wash. Then I started adding color and form with the Pris-
macolor pencils. When working with these pencils, it's only possible to build
up your color layers a certain amount, after which it's difficult to add more
tones. I soon reached that point on this drawing, so I sprayed the drawing
with a workable fixative that allowed me to continue working without any
problem. Oil crayons were also used on this drawing, and most of the back-
ground was done using them.

Demonstration 13. Color Pencils with Dyes and Ink

Dyes work very well when combined with pencil drawings. You can just use a few simple, flat washes of color to create very effective drawings. I should remind you that when painting, you should always use the finest quality red sable brushes, as cheap brushes do not work well.

Step 1. Using a medium warm gray 962 Prismacolor pencil, I do my basic drawing on a four-ply Strathmore regular-surface bristol board. I then mix a bright orange from Dr. Martin's dyes, using pumpkin and amber yellow. I wash color on the appropriate areas with a large number 8 red sable watercolor brush.

Step 2. Using water-soluble ink, I add the dark markings to the dog's back and indicate a few details on its head, such as the eyes and nose. With a light flesh 927 pencil, I add a tone to the face.

Step 3. With a warm gray 962 pencil I begin to add shadow tones and details to the dog's head and various parts of the body. For the shadow tone on the white area of the fur, I use a light, cold gray 968. I now add a little light fleshtone to the dog's face.

Step 4. I continue to add subtle shadow tones with the medium gray and darken the fur color using an orange 918 over the washes. I finish the eyes and nose details with the black pencil, and on the tongue I use flesh 927 and pink 929 pencils. I then use the black pencil over some of the fur tones and also over the shadow areas to intensify them.

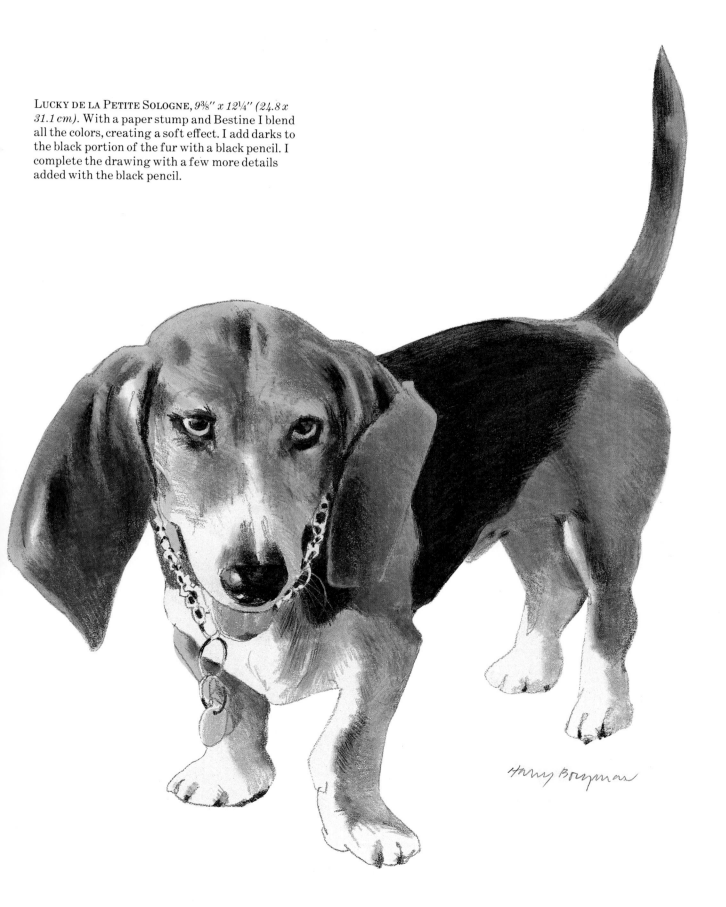

LUCKY DE LA PETITE SOLOGNE, *9⅜″ x 12¼″ (24.8 x 31.1 cm)*. With a paper stump and Bestine I blend all the colors, creating a soft effect. I add darks to the black portion of the fur with a black pencil. I complete the drawing with a few more details added with the black pencil.

Demonstration 14. Color Pencils, Oil Crayons, and Gouache

Gouache or Designer's Colors work very well when combined with color pencil and oil crayons. Just a simple wash of color will work quite well; you don't have to get very involved with painting when using this technique. Working with opaque paints and pencils will help to prepare you for working with these other mediums.

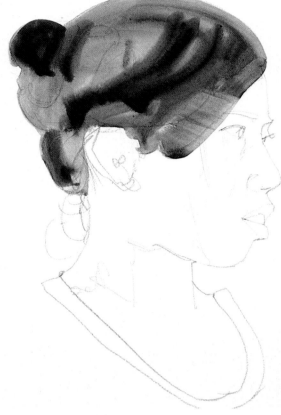

Step 1. I do a line drawing on Strathmore four-ply regular-surface bristol, using a medium-warm gray 962 Prismacolor pencil. I wash Designer's Colors ivory black over the hair portion of the drawing.

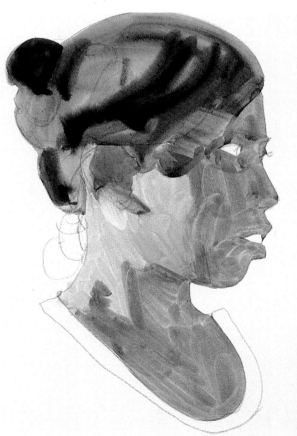

Step 2. On the highlight portion of the face I wash a tone of raw umber and then a wash mixture of raw umber and black on the shadow area.

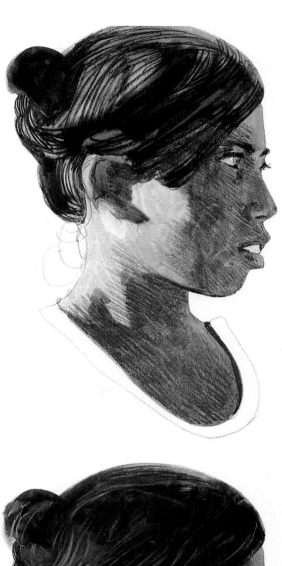

Step 3. I begin to draw in the facial details, the nose, the eyes, and the mouth with a black pencil and use the nonphotographic blue 919 for the reflected light in the shadow portion of the face. I then add burnt umber 947 over the shadow tone on the face, and with the black pencil, I draw a line texture in the hair.

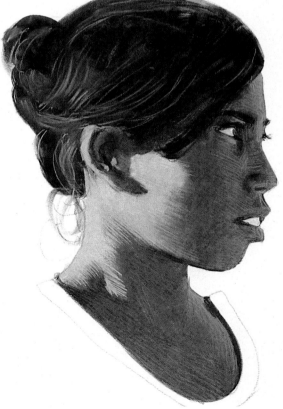

Step 4. With a Neo-color oil crayon, russet 056, I add color to the shadow portion of the face. Then, using a Neo-color salmon 31, I add additional color to the highlight areas. I use Neo-color grays on the hair and soften these lines with Bestine and a paper stump.

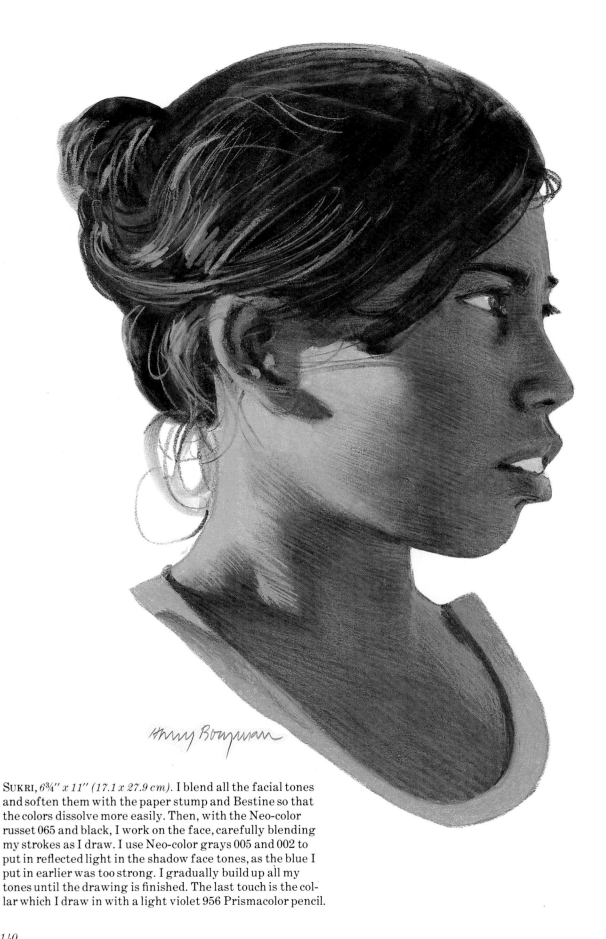

SUKRI, *6¾″ x 11″ (17.1 x 27.9 cm)*. I blend all the facial tones
and soften them with the paper stump and Bestine so that
the colors dissolve more easily. Then, with the Neo-color
russet 065 and black, I work on the face, carefully blending
my strokes as I draw. I use Neo-color grays 005 and 002 to
put in reflected light in the shadow face tones, as the blue I
put in earlier was too strong. I gradually build up all my
tones until the drawing is finished. The last touch is the col-
lar which I draw in with a light violet 956 Prismacolor pencil.

Demonstration 15. Color Pencils and Acrylic Paint

Acrylic paint is another medium that can work quite well with color pencils. If you try to keep everything very simple, you shouldn't have too much trouble with this technique. Usually a simple color wash will work out just fine. This is not really like doing a painting; the paint, in this case, just supplements your pencil drawing.

Step 1. I first draw the scene on Strathmore regular-surface bristol board with a 2H graphite pencil. Next I mix a wash, combining cobalt blue, Mars black, and titanium white, which I paint over the foreground shadow area. Then I mix titanium white, cadmium yellow, and a little cobalt blue and paint it on the sky portion of the picture. I use the paint rather thick here so that it will dry evenly without any texture.

Step 2. I mix orange and titanium white and paint this color on the distant mountains. I paint the snow in with white paint.

Step 3. I begin to draw with a color pencil, using Copenhagen blue 906 on the mountain shadows. I also add sienna brown 945 on the mountain. I go over this with a slight tone of pink 929. I also add the pink to the hill just in front of the mountain. With a light cold gray, I draw in some bushes in the middleground. Now I begin working on the foreground bushes.

Step 4. I finish the foreground bushes and add light flesh 927 and flesh 939 over the foreground rock formation. I use black over this to draw in the shadows and other details, and darken the hill in the middleground with a medium warm gray 962 pencil. I then soften some of these tones with Bestine and a paper stump.

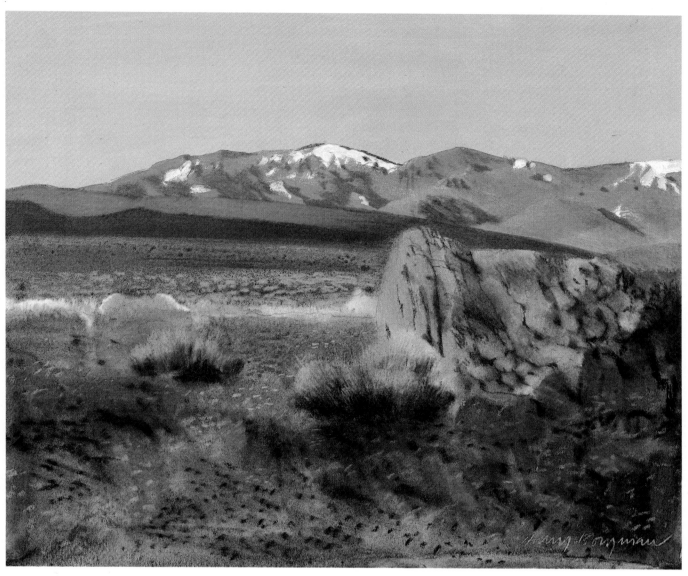

NEVADA DAWN, *11¾″ x 10″ (29.8 x 25.4 cm)*. I add more rocks and pebbles over the ground area and then draw in more cracks and shadows in the foreground boulder. I soften and blend all these tones with the paper stump, which finishes the drawing.

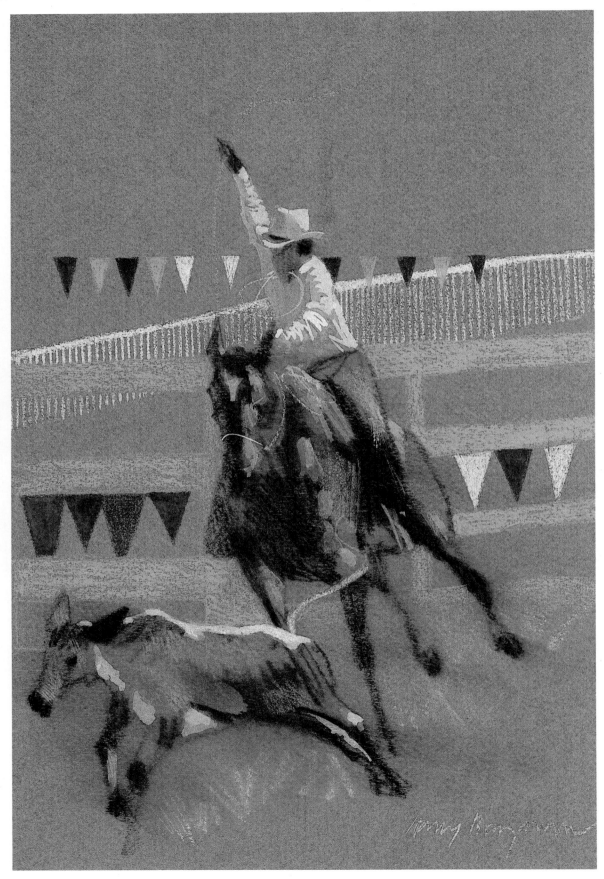

Realistic Line and Acrylic Paint

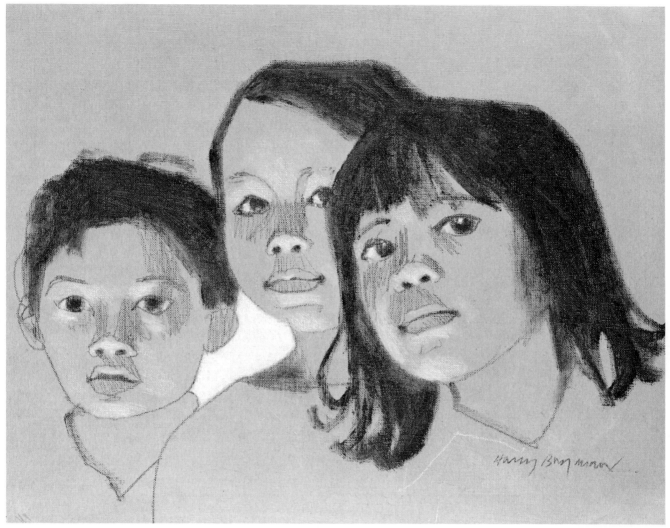

Above. BALINESE CHILDREN, *9¾″ x 12″ (24.8 x 30.5 cm).* This drawing was done on canvas, which is quite compatible with pencil. I first mixed a gray tone from Mars black and titanium white Liquitex acrylic paint. This tone was painted on the canvas surface with a flat bristle brush. When this tone dried completely, I did my basic drawing with a black Prismacolor pencil. Next, using a white Stabilo pencil, I carefully drew in the reflected light areas on the faces. The hair was painted in with black acrylic paint, as were the eyes. For added design interest, I filled in the area between the boy and girl, using white pencil. Very interesting effects are possible with this technique.

Left. RODEO ACTION, *7⅝″ x 11½″ (19.4 x 29.4 cm)* The horse and calf were first sketched in, then softened with a rag dampened with turpentine. White washes of opaque Designer's Colors were then added to the rider's shirt and hat and to the markings on the calf. The background fences and flags were put in last.

Realistic Dissolved Tone on Colored Paper

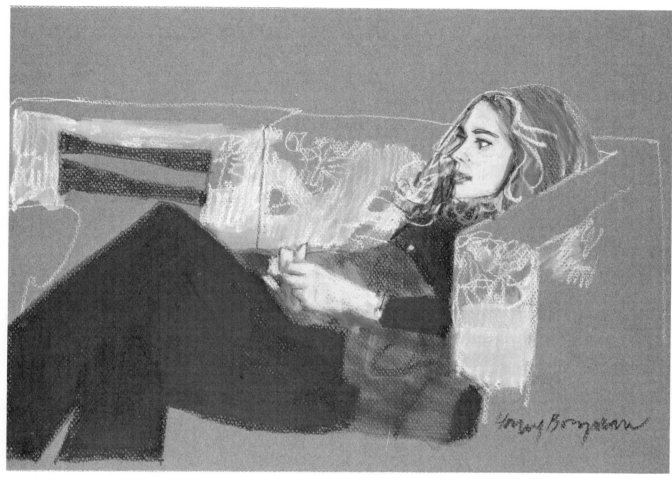

Above. SEATED WOMAN, *15¼″ x 11″ (38.7 x 28 cm).* I first did a quick sketch of the lighter parts of this scene with a white Stabilo pencil. Then I used a black Stabilo pencil to draw in the darker objects such as the girl's clothes, facial details, and the pillow. I used a wash of clear water to dissolve certain areas on the couch and in her face, and with a black oil crayon drew in the dark shapes of her clothes and the pillow stripes. I then dissolved the black oil crayon with a rag and turpentine, rubbing these areas into a smooth jet-black tone. I used light gray oil crayons to draw in her face and hands and drew in the final details—eyes, nose, and mouth—with the Stabilo black pencil.

Right. CARCASSONE, *6½ x 13″ (16.5 x 33 cm).* This drawing was done on a gray paper, using white and black Stabilo pencils and oil crayons. Many of the gray tones were blended with a rag and turpentine.

Decorative Dissolved Tone and Paint on Colored paper

ROME, *9⅞″ x 11″ (25.1 x 27.9 cm)*. Graphite pencil and water-soluble ink were used on MBM Ingres d'Arches paper for this basic line drawing. The tones were washed over with a watercolor brush. To achieve the soft cloud effect, the paper in this area was first dampened with clear water. The ink wash was then applied over this, causing the edges to blend.

CASTEL SANT ANGELO, ROME, *12½″ x 11¾″ (31.7 x 29.8 cm)*. Graphite pencil, black Prismacolor pencil, and opaque gouache washes were used on a smooth bristol for this rendering. The basic line drawing was done first, and then a gray wash, mixed from Designer's Colors ivory black, and permanent white, was painted over the appropriate areas. The black accents in the building were drawn in with the Prismacolor pencil. This is a fresh, quick technique that can be used for outdoor sketching.

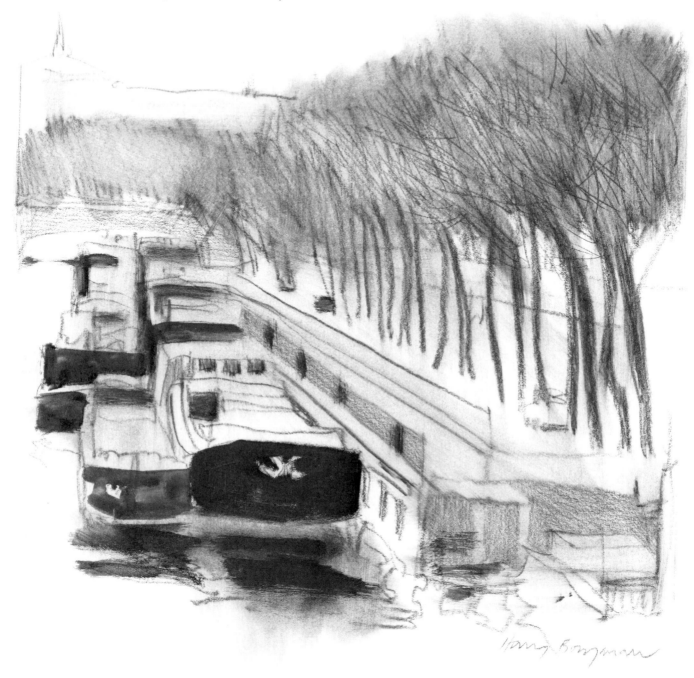

BARGES ALONG THE SEINE, *10⅝″ x 10⅝″ (27 x 27 cm)*. This study was drawn
with a Stabilo black pencil. A rag dampened with turpentine was used to
blend and smudge certain areas, dissolving the pencil tones into a gray wash.
Parts of the drawing that had dissolved were redrawn and the tree branches
were added. The deep black areas on the boats and in the water reflections
were painted in with Designer's Colors ivory black.

Chapter Eight
Technical Tips

In this chapter I will review various technical and useful points. Many of these points have been covered in previous chapters, but discussing them together and in more detail should prove helpful.

There are many drawing problems that you can become aware of only through experience. Many of these problems are taken for granted and seem relatively unimportant, but they really aren't. Some of these problems include: how to sharpen a pencil correctly; how to keep drawings clean; how to handle tough erasures; how to protect your drawings; and drawing from life, models, and photographs. These are all problems you will be confronted with, and they are important to think about.

In this chapter I will discuss a few of these basic problems and give you a few suggestions on how to develop yourself as an artist.

Sharpening Pencils

It's really much better to sharpen your pencils with a single-edge razor blade or an X-acto knife and then to shape the lead with a sandpaper block. Forget about using a hand or mechanical pencil sharpener. You can do a much more professional job of sharpening with the other method.

First cut away the wood from around the lead, making sure you don't cut away the identity number of the pencil. Yes, there is a wrong and right end of a pencil to sharpen. On the harder grades, 9H through HB, you can cut away more of the wood, leaving a rather long lead that can be shaped with a sanding block. Be really careful when sharpening the softer grade leads, B–6B, as they break easier. With them it's best to cut less wood away, leaving a short lead. The points, after sharpening, can be shaped in many

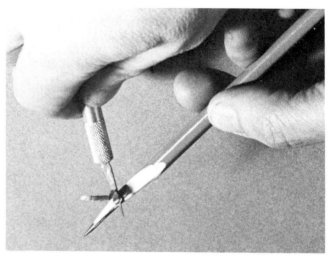

This is the best way to sharpen a pencil. Use a single-edge razor blade or an X-acto knife to first cut away the wood from around the lead and then shape the lead with a sandpaper block.

ways, depending on the effect you want in your drawing. The point can be blunt, chiseled, or needle sharp.

Another way to achieve different effects in your drawings is to try holding the pencil in different ways. Normally while working and sitting at a drawing table or desk, you would hold the pencil in much the same position as you would for writing. You will find that if you stand while drawing, you will hold the pencil differently from when you are sitting. The angle of your drawing board will also determine how you hold your pencil. When doing a tight, meticulous rendering, you will hold the pencil quite differently from when you are doing a rough sketch. Experiment with different hand positions and ways of holding the pencil.

If you sharpen several pencils at a time, you can draw longer without interruptions—a very good thing to keep in mind. Remember, too, you must be especially careful when

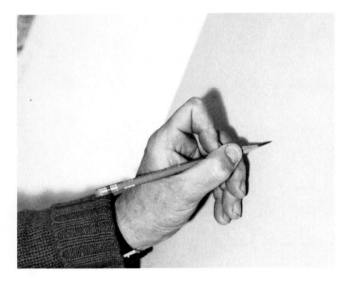

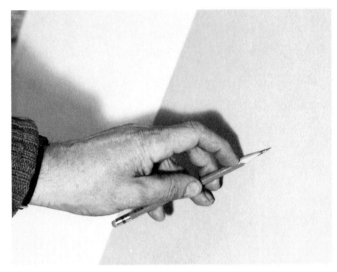

These are different positions that can be used for holding your pencil when drawing. Experiment with some of these to see which ones suit you best.

sharpening charcoal, carbon, pastel, and wax pencils, since they are generally a little more brittle than graphite pencils. Of course you can always draw with a mechanical pencil or a lead holder, but you won't achieve the variety of lines possible with a regular pencil. Most leads for mechanical pencils are quite thin and are not easily shaped.

Keeping Your Drawings Clean

Since drawing with most pencils can be quite messy, certain precautions are advisable. Try remembering to use a piece of tracing paper under your hand when drawing. This can help a great deal in keeping your work clean. Often, especially when using charcoal,

carbon, or pastel pencils, pencil dust will cover your paper. Usually this can be blown off, and it should be at frequent intervals. If you don't get rid of such pencil residue, it will show up much more after you've used a fixative on your drawing.

To be certain you've gotten rid of this unsightly residue, you can carefully erase the white paper areas of your drawing with a kneaded rubber eraser. Since the eraser can be easily shaped, you can erase in very tight spots. You can also confine your erasures by using an erasing shield for certain areas. For very difficult erasures, try a fiberglass eraser. But these erasers can only be used on robust surfaces, such as illustration boards, because they cut surfaces.

Preserving Your Drawings

The best way to preserve a pencil drawing is to spray it with a varnishlike fluid called a fixative. If you don't fix your drawings, they may become smudged or otherwise damaged.

Fixative is available in a spray can or in a bottle for use with an atomizer. Since a more even coat of fixative can be attained with a spray can, I recommend using this type. Fixative is available in either glossy or nonglossy, also called matte finish. The latter is preferred for pencil drawings.

To properly fix a drawing, tape the drawing to your drawing board and set it somewhat vertically against a wall. Hold the spray can about 15-20 inches away from your drawing. Then spray a light coat on the artwork, moving the can back and forth until an even coat has been attained. Two or three light coats are preferable to one heavy coat, since the fixative will ruin your drawing if it begins to run. First practice spraying rough sketches until you have learned to control the spray. Because some brands of fixative have a strong odor, you may prefer the odorless variety, as I do. Also be careful not to spray surrounding objects when fixing your drawings. In fact, just to be on the safe side, do

To spray a drawing properly with fixative, hold the can about 15 or 20 inches away from your drawing, which should be in an upright position. Using a side-to-side motion, apply a light coat of fixative, but be careful not to overspray or flood the surface, as this will probably ruin your drawing. Two or three light coats of fixative are much better than one heavy coat.

A kneaded eraser is very handy, as it can easily be shaped for special erasing problems. You can even draw into pencil tones with this eraser.

This is a convenient collapsible stool that can be used when you draw outdoors. It folds up for easy carrying and can be unfolded when you need it.

your spraying in the basement or garage.

By the way, there is a fixative on the market that enables you to continue working on your drawing after it has been fixed. You can fix newly drawn areas with a light spray.

Drawing From Life

Recruit family members and friends as models. If you feel a little uneasy about drawing in front of someone, take a few Polaroid photographs of your subject and work from them. This way your subject won't get impatient or move while you're working. You will also be much more relaxed, which will enhance your ability to work. One subject that won't move is a still life. You can easily set up a simple still life of fruits or flowers and leisurely draw them. The most convenient way to draw from life is to work directly on a sketch pad. You can also tape a piece of drawing paper to a portable drawing board. But a sketch pad is really more convenient, since all your drawings will be in one place. Making comparisons or finding references is then much easier. Sketchbooks are also best if you will be drawing while traveling or on vacation. Your sketches can then provide an interesting and easily accessible record of your travels.

For outdoor sketching, the same basic equipment works well. You might want to buy a small portable stool, however, which folds up for easy carrying. If at first you feel a little uncomfortable about drawing outside, work from Polaroid photographs or regular photographic prints for a while. When you become surer of yourself, take the big step and draw on location. Actually, drawing on location is fascinating, and you invariably meet some interesting people.

Drawing From Photographs

The Polaroid camera is a convenient tool, since you can quickly see the picture you've taken. Polaroid photographs are, however, rather small and can be difficult to work from. So I prefer working from larger prints

whose details are clearer. I usually shoot most of my reference photographs with a 35mm reflex or range-finder camera. I then move the photographs blown up into 8″ x 10″ prints.

If you are going to draw, you should own a camera. But it needn't be an expensive one. Check some of the used camera bargains in newspaper ads or at your local camera shop. Your best choice would be a 35mm reflex-type camera.

All 35 mm film comes in either 20- or 36-exposure rolls, and your negatives can be printed together on a contact sheet. Such sheets will enable you to see a roll of pictures at one time. If you want to later blow up some pictures, you can order them from your contact sheet. But be sure to keep your negatives with the contact sheets so they can be easily found. Contact sheets will also help you to become organized, as many professional artists have discovered.

By using the 35mm method, you can also

A Polaroid camera is very handy. This is an older model that I picked up secondhand. It even has a close-up and portrait lens attachment.

take color slides. Such slides also make good reference photographs.

A Review of Some Important Points

First be sure to study all the technique examples and step-by-step demonstrations. Go over these examples carefully until you understand how they were done. The step-by-step demonstrations are especially important because you can study the drawings at their· various stages. At first the diverse number of technique examples may seem confusing, but as you study them you will begin to understand how they were done. Even the differences in styles will become more apparent as you develop your drawing skills.

When you begin working with the techniques, don't work on several at a time. Stick to one technique until you feel you have mastered it. Then go to another one. Also, practice all the pencil exercises as I have suggested, for they will provide background for later techniques. They will also familiarize you with the various drawing tools and paper surfaces.

When attempting any of the techniques, be sure to begin with simple subject matter. And keep your drawings small until your skills are developed. This way you won't get discouraged and will progress rapidly. After you feel at ease with the simpler techniques, move to the more complicated tone techniques. Then progress to the full tonal drawings without lines. When you start working with mixed media, begin by doing simple line drawings, using simple, flat washes of water-soluble ink for tones.

I cannot stress enough the importance of practicing often. If you were trying to learn to play the piano, you would practice a great deal. The same holds true for drawing and painting. It is also advisable for you to enroll in a basic-drawing or a life-drawing class.

Many schools offer such classes in the evenings or on Saturdays. Working with a competent art instructor will be very helpful. Meeting other art students is also important, for it will give you the opportunity to see others work and to discuss art with people who share your interest. Try to expose yourself to as much art as possible by going to galleries and museums where you can study drawings and paintings. Such trips can be quite stimulating and inspiring.

There are also many books and magazines on art, which can be found in your local library. You might even want to purchase a few good books for handy reference material. Everything you see and read about art will help you develop as an artist.

Remember what I said about discipline—it is an extremely important part of being an artist. You must be SELF-MOTIVATED.

Drawing, and especially learning how to draw, may seem to you to be quite a chore, but it needn't be if you approach it with the right attitude. Try to look at drawing as a wonderful learning process, a very exciting new world. If you are determined, you will work hard and will probably be quite encouraged at your own progress over a short period of time. For this reason, it is a good idea to keep all of your drawings and sketches so you can compare your older work with your latest endeavors. You will actually be able to see how much progress you have made over a period of time.

Drawing should be a pleasure instead of a chore, and as you progress and develop, it will become much easier for you. It will be tough at the beginning, but when some of the mystery is taken out of drawing through your own experience, and you feel more sure of yourself because of your development, then drawing will become a pleasure as well as a challenge.

I usually use a 35 mm camera for my reference photographs and have the film developed by a lab that prints the negatives in the form of a contact sheet. With this sheet I can see at a glance what subjects are on a set of negatives. Then I can order larger prints later when I need them. This is an excellent way to keep track of your reference photographs.

Index

Edited by Connie Buckley
Designed by Jim LaTuga
Set in 12 point Century Expanded